BREEN
DAMAGE

A collection of cartoons by Steve Breen

Pulitzer Prize-winning
editorial cartoonist for the

ASBURY PARK
PRESS

Steve Breen

Limited Edition. Signed and Numbered by Steve Breen.
Number _852_ of 1,500.

For Cathy and Thomas,
With Love and Gratitude

Acknowledgements

I would like to give special thanks to Paul and Joanne Breen, Greg, Mary, Erin, Jim, Megan and Bridget – Pat and Bud Macfarlane, Loretta Breen, Doug and Sue Breen, Bruce and Jane Reynolds, Dick and Mary Locher, Jimmy Margulies, Mike Peters, Walt Handlesman, Mike Ramirez, Bob Witty, Glenda Winders, Pat Gonzales, Ray Ollwerther, Andy Sharp, Ed Gabel, Harris Siegel, Shannon Mullen, Bill Neubeck, Andy Prendimano, Mark Voger, Bob Collins, Don Lass, Jules Plangere Jr., all my friends at the Press and, most importantly, the readers of Gannett New Jersey Newspapers.

I also would like to recognize the efforts of the Press Marketing Department — including Evelyn McConnell, Kathy O'Connor, John Oswald, and Catherine Bradford — for their contributions to this book.

— Steve Breen

Table of Contents

Foreword

People are forever trying to give me credit for Steve Breen's success. I categorically reject this. All credit belongs to Steve.

When I met Steve, he was a callow freshman at the University of California at Riverside. I was the adviser for the school newspaper, and he was drawing gag cartoons.

After some years as a newspaper editor, I knew this kid could draw. I also knew the story of Pulitzer Prize-winning cartoonist Jeff MacNelly, and how he got his start at the University of North Carolina. It occurred to me that UCR might have just such a prodigy on its hands. I suggested to Steve that he give editorial cartooning a tumble. His response: What's editorial cartooning?

He learned by spending hours in the university library, investigating the techniques of MacNelly, Pat Oliphant and other great inkers. And he learned what it took to provoke thoughts with images. What's more, he discovered he liked the effect his drawings had on people.

A few years later when Steve called to tell me he had won the Pulitzer Prize, I had trouble believing him. He was too young. It was too soon.

But when I looked at the portfolio he had submitted to the Pulitzer panel, I saw how he had matured, how his cartoons had taken on greater depth and perspective, how his understanding of issues had become deeper and more enlightened. In short, he was more provocative, and the judges recognized the excellence of his work. He deserved the Pulitzer, despite being just 27.

He is, to me, a true political scientist. He studied poly-sci, but it goes well beyond that. Steve appreciates history, and he understands its relationship to events that take place today. He studies human nature and recognizes how issues affect us, and we are the beneficiaries of his insights. And if there's a bubble of self-importance floating around out there, Steve will pierce it with his pen. Just ask Governor Whitman.

In the years that I have known Steve, I've seen him grow as a man and as a cartoonist, while maintaining the values he showed as a college freshman: honesty, generosity, compassion, competitiveness, determination, a passion for self-improvement, and a full-court-press sense of humor, buttressed by a cartoonist's irreverence and laser wit.

Steve's twin anchors are his faith and his family. He shares his life with his wife Cathy and their son Thomas in a cozy 1883 Victorian. I have gotten to know his parents and his siblings. They have much to be proud of as Steve is an extension of them all.

Steve may be the most genuine person I know, and the most sincere, despite his assassin's instinct at the drawing board.

Take a look through this book. You'll see what I mean.

Bruce Reynolds

From the Editor

Steve Breen likes to tell people that he began work at the Asbury Park Press as a janitor, and that he was offered the job of editorial cartoonist after he was spotted one winter's day sketching a caricature of the president on a frosted window in the lobby.

It didn't happen that way, of course. But Steve did pay his dues. When he applied for a job at the Press in the summer of 1994, as a young high school teacher with a batch of editorial cartoons in hand, there was no fulltime cartooning position to offer him. So we gave Steve the opportunity to produce cartoons while spending most of his workweek handling other duties: working as a paginator, electronically assembling pages on a computer screen. This was not a happy job match, to say the least, as we quickly learned that Steve's technological skills fell woefully short of his drawing abilities.

Steve then took on some illustration duties in the art department, including the caricatures that he does so well. After discovering that Steve was spending hours producing original farewell cards for departing employees and caricaturing dozens of newsroom staffers, we decided to make Steve a fulltime editorial cartoonist. During his first full year in the position, he produced the work that would bring him journalism's highest honor, the Pulitzer Prize.

Steve's cartoons are well-drawn, carefully composed and thought-provoking. His work is the product of a rare combination of intelligence, wit, decency and empathy.

Here at the Press, we're proud to have helped encourage such exceptional talent – and to have assembled the best of Steve's work to date. Enjoy!

W. Raymond Ollwerther
Executive Editor and Vice President/News

West Winging It

The White House

Sex. Scandal. Intrigue. And a nose that's easy to draw. Bill Clinton's got it all, and he brought it to the White House. The president, and those he gathered about him, proved to be an embarrassment of riches for us editorial cartoonists. Even Buddy, the presidential pet, wasn't spared.

Will I miss Bill's bulbous nose or his questionable judgment when it comes to the White House help? Maybe. But there's a new cast of characters waiting in the wings at 1600 Pennsylvania Ave., and I'm sure they won't let us down.

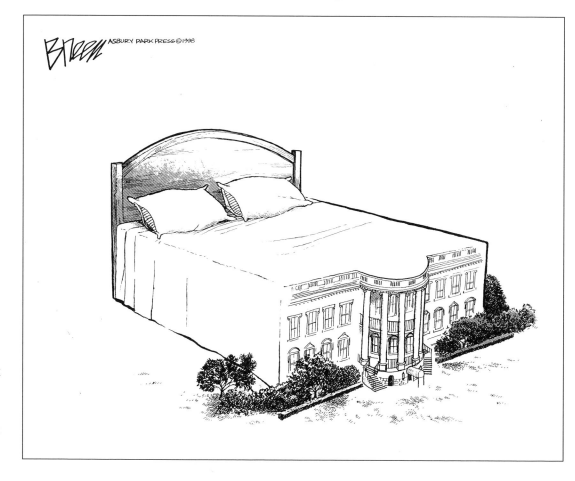

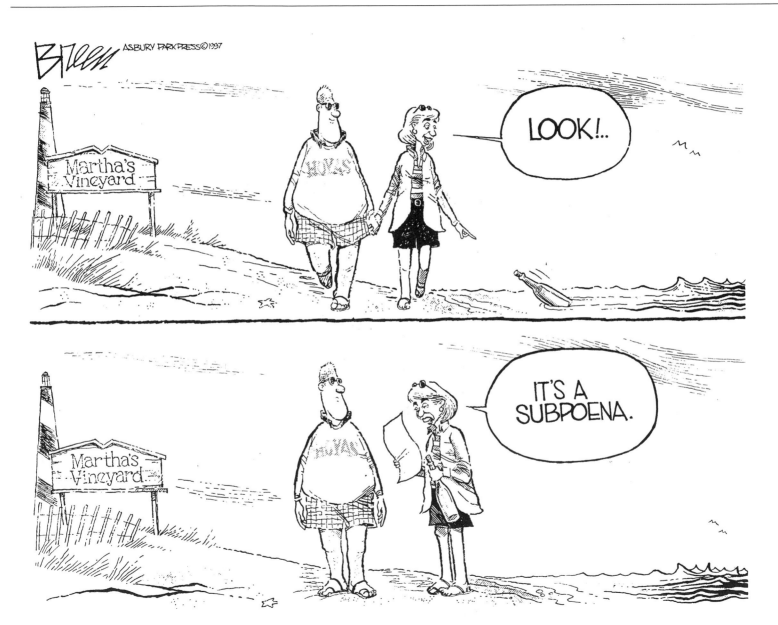

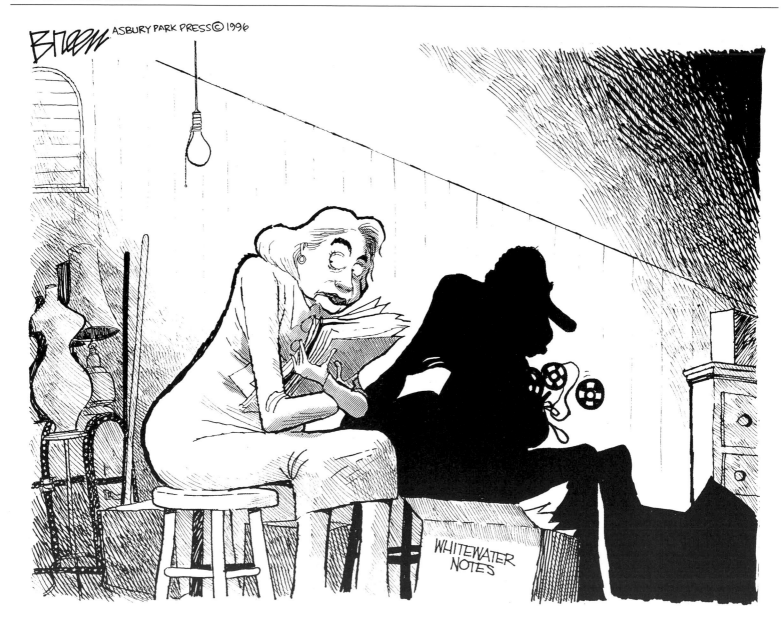

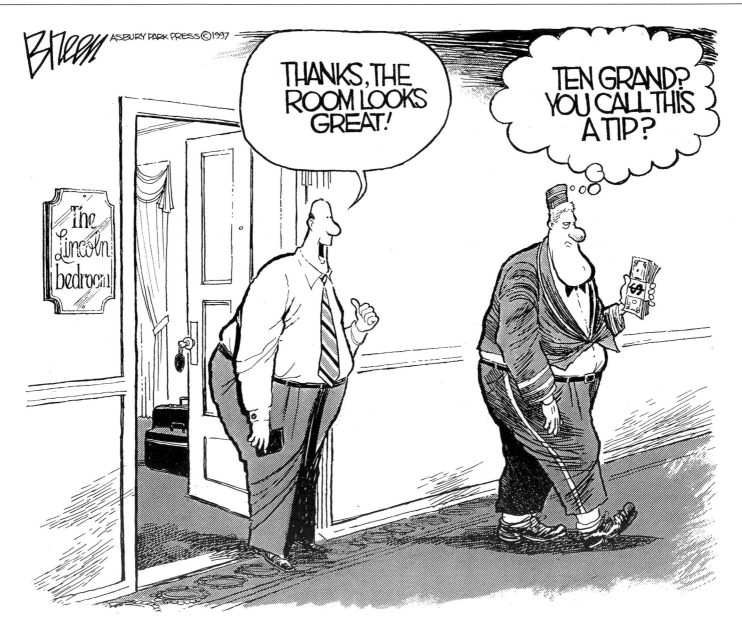

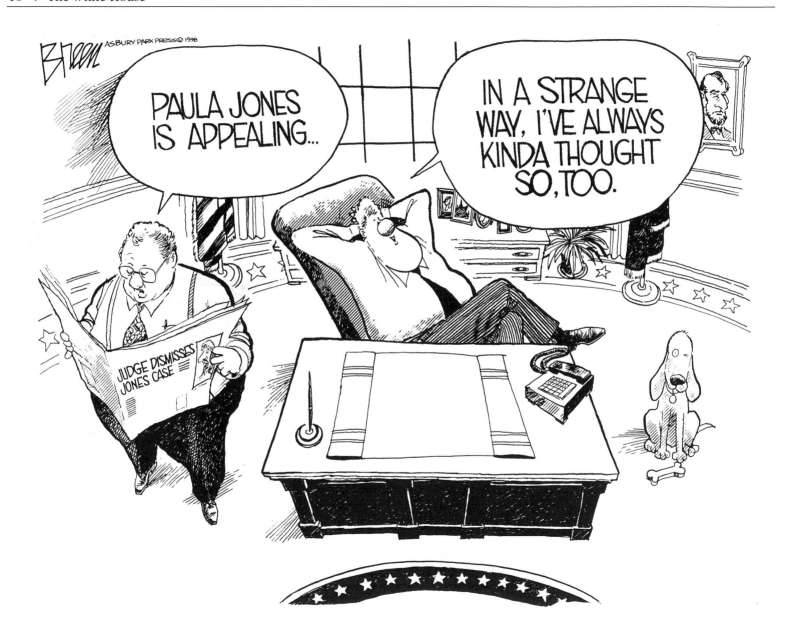

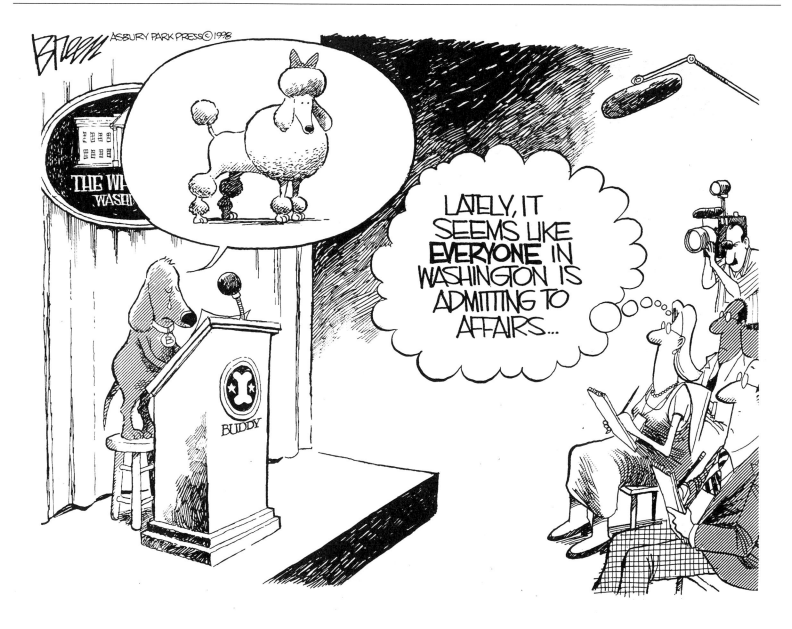

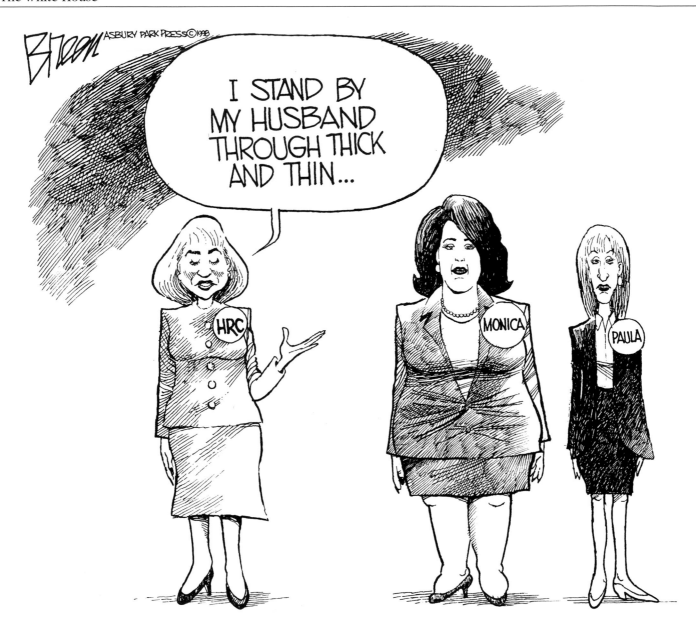

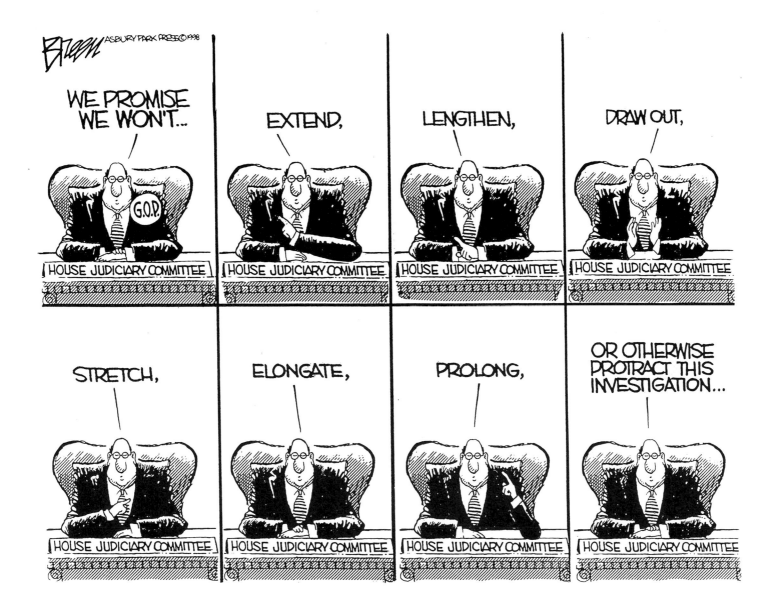

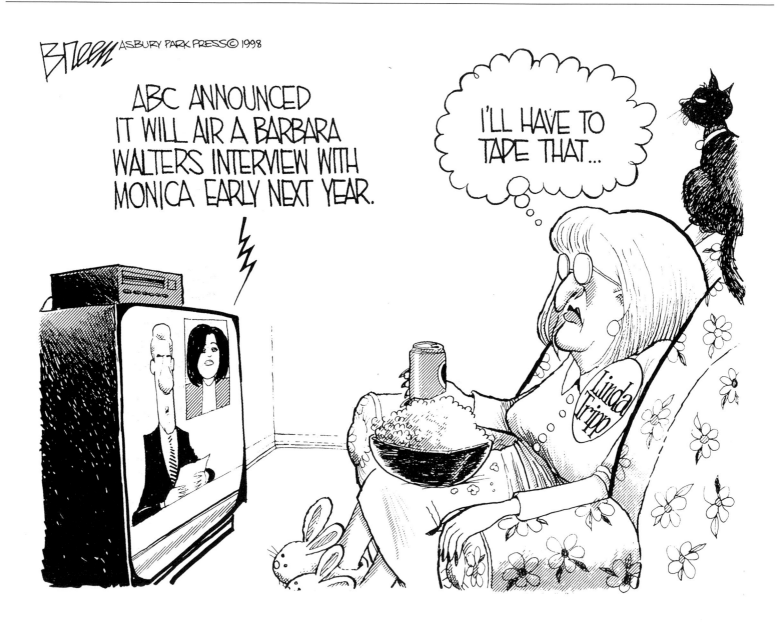

Chapter One

It was the best of times, it was, like, the worst of times...whatever.

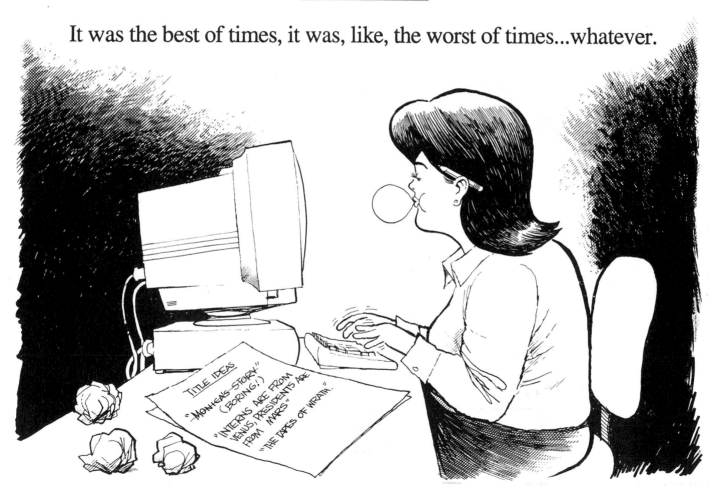

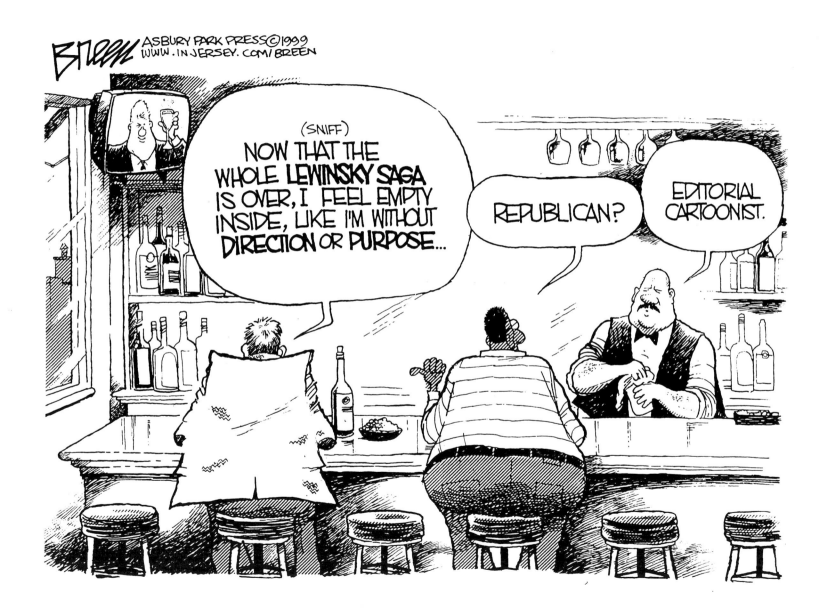

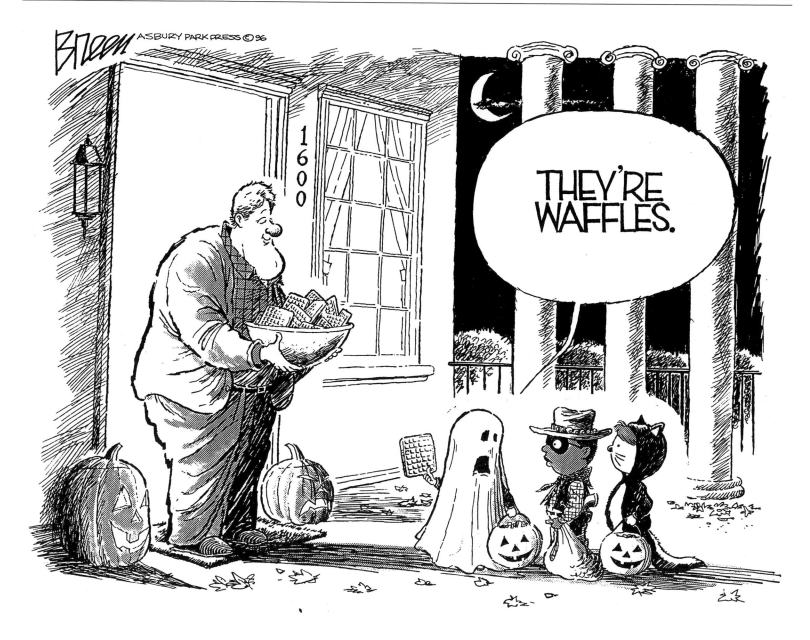

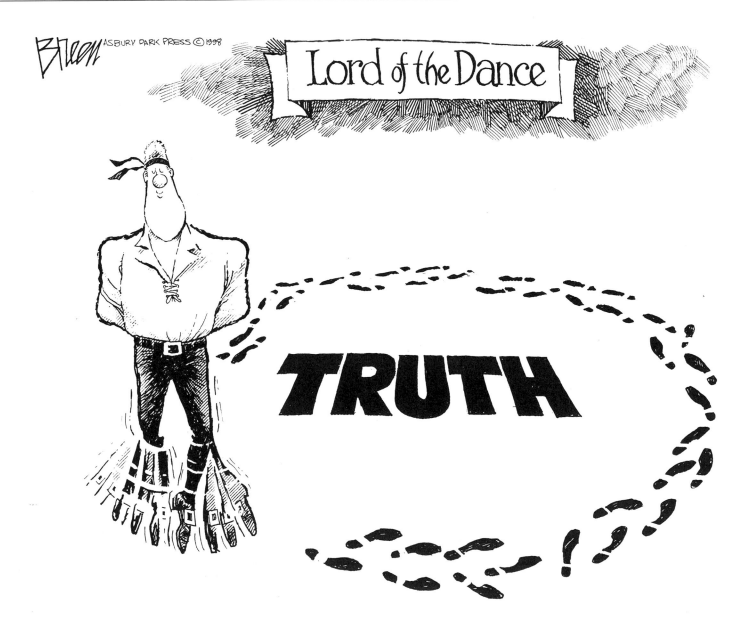

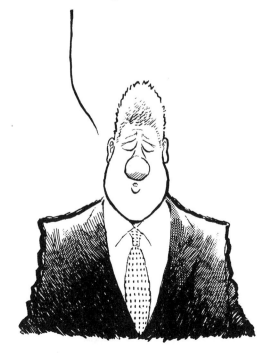

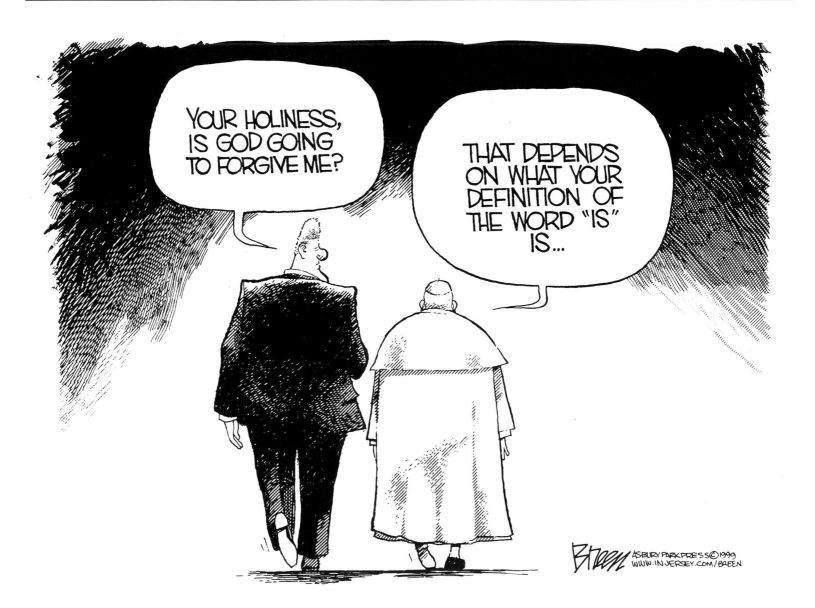

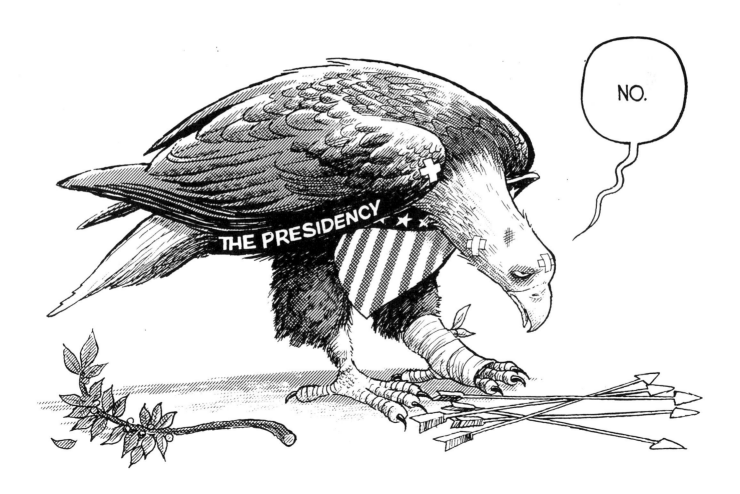

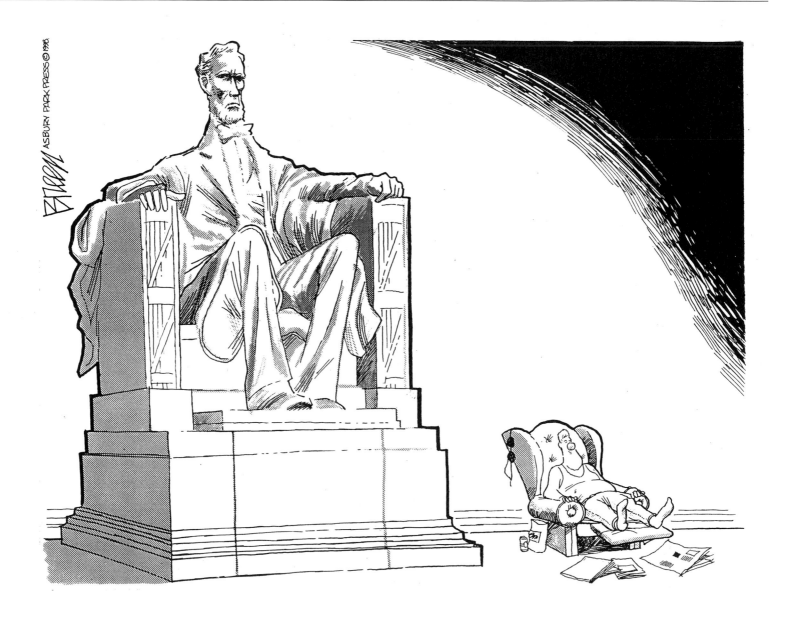

Global Warnings

International

America hasn't cornered the market on lunacy. The world is a crazy place.

There will always be a despot in need of deflation, a crisis requiring a closer look or a world event begging for a simple, hopefully humorous, explanation.

I've no designs on solving the world's problems. I'd just like to shed some light on them.

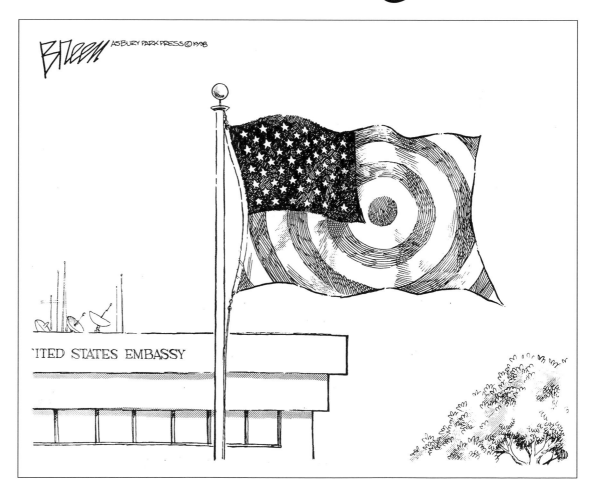

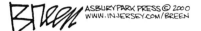

MIAMI VISE

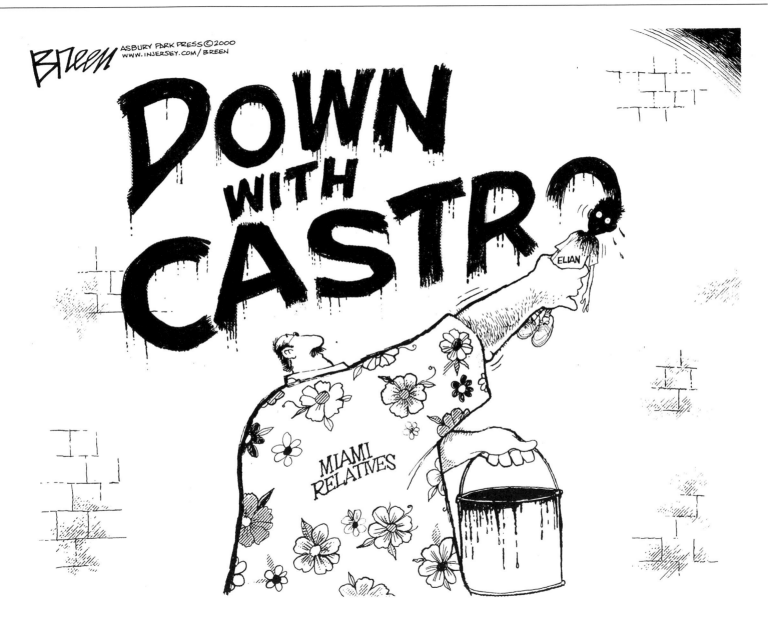

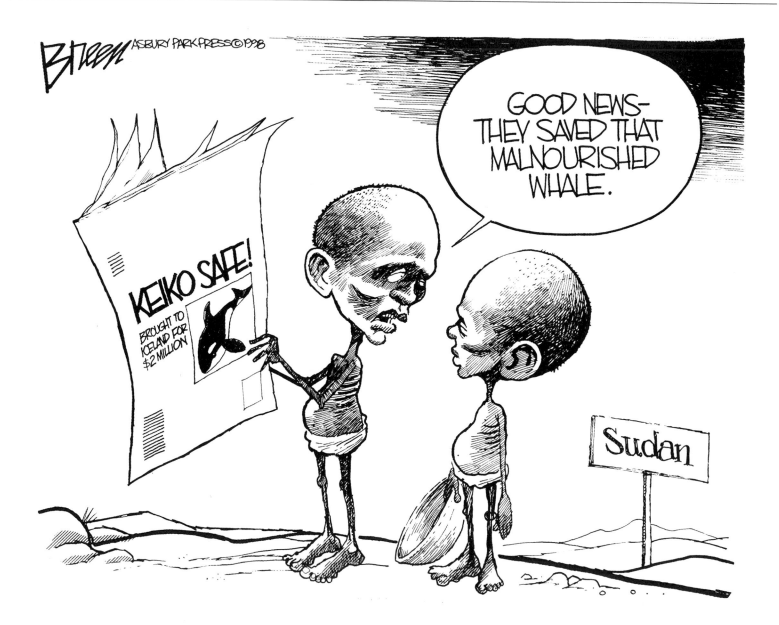

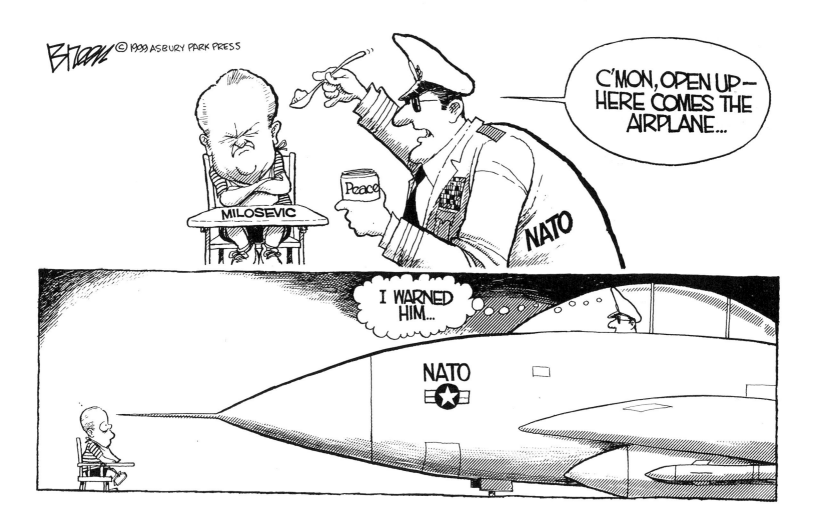

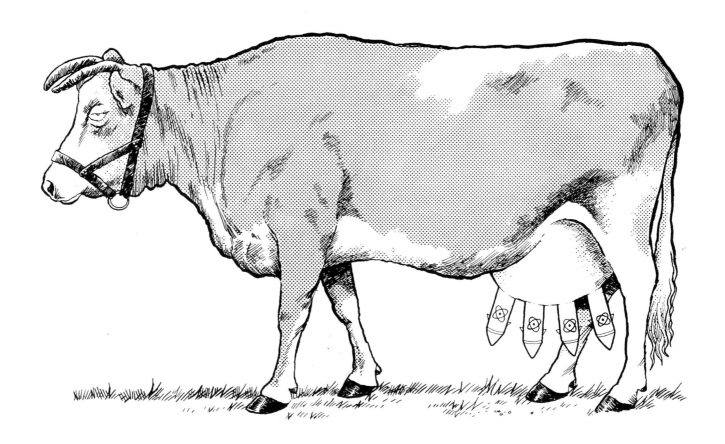

INDIA'S SACRED COW

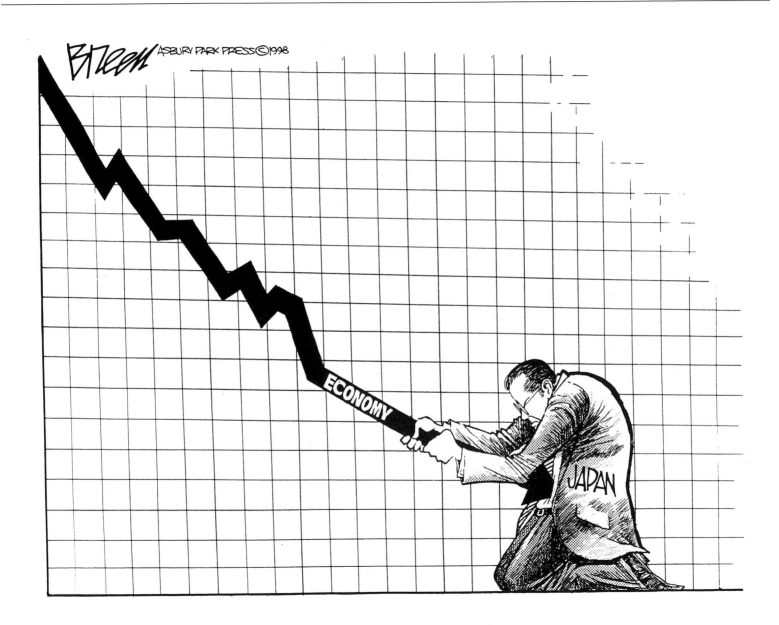

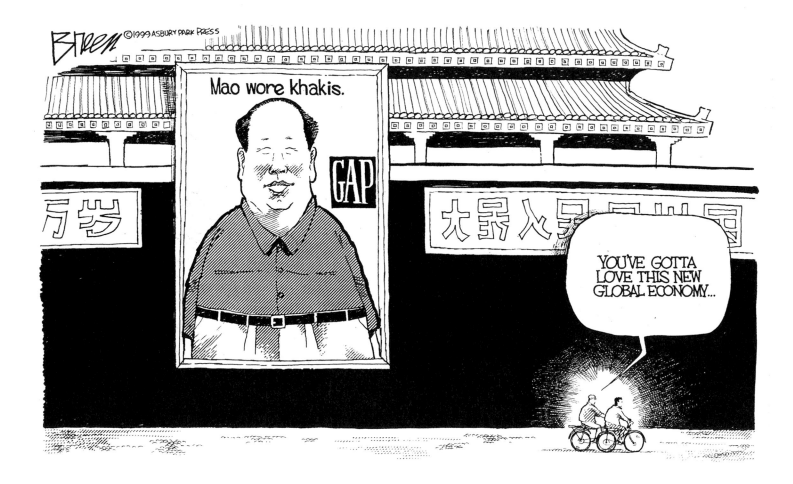

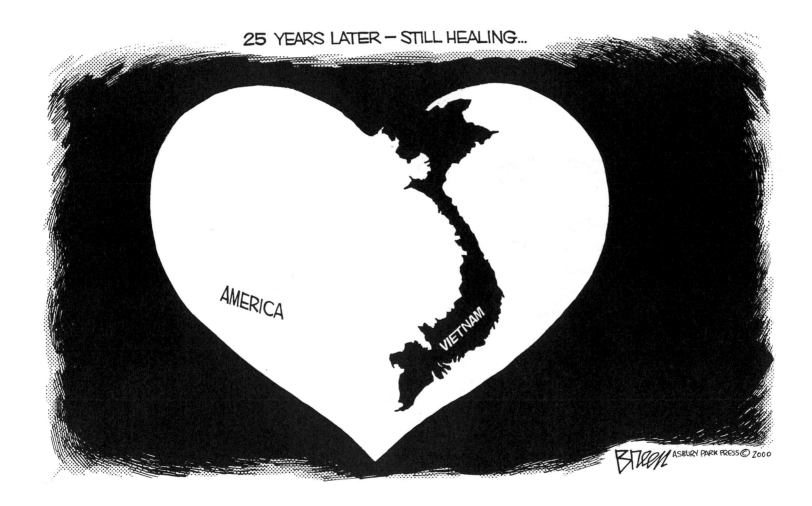

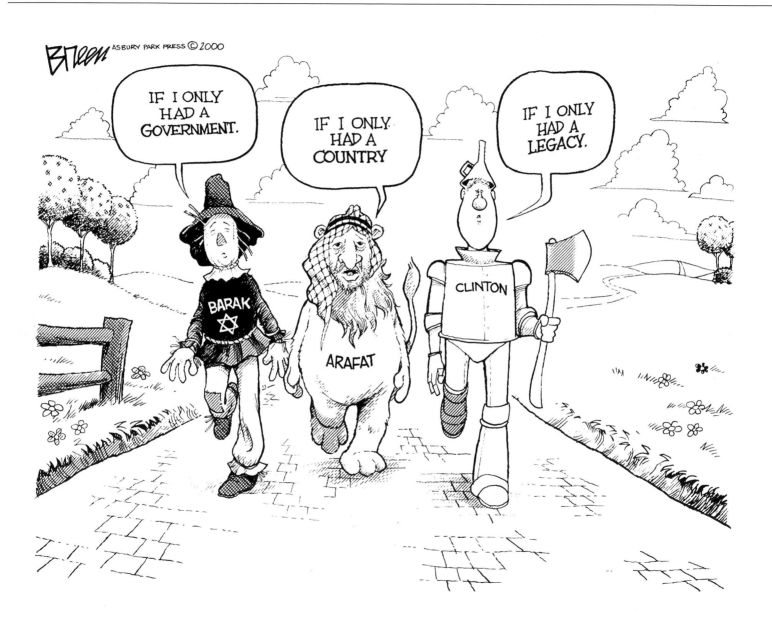

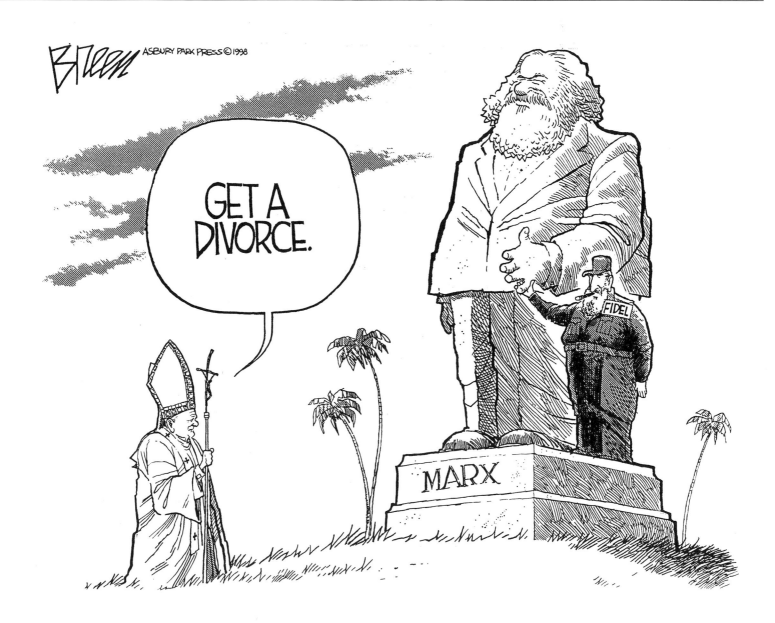

Take Me To Your Leader

Politics

Politicians and cartoonists have been joined at the hip ever since candidates started kissing babies. We're drawn to their pomposity and self-importance like a candidate to a fundraiser.

A good political cartoon cuts through the rhetoric, makes a complex issue easier to understand and helps expose a politician's weaknesses to the world. Not to mention their big ears.

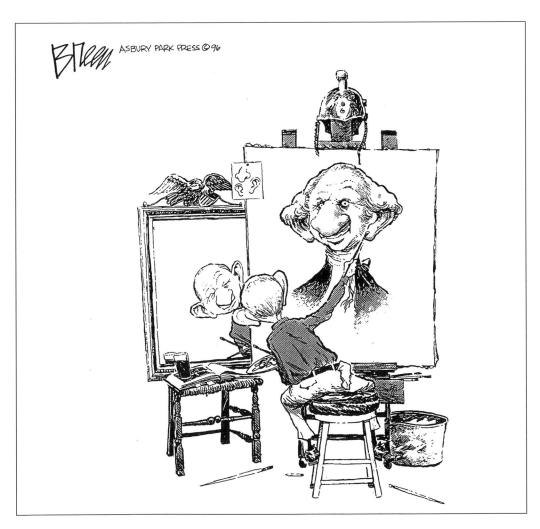

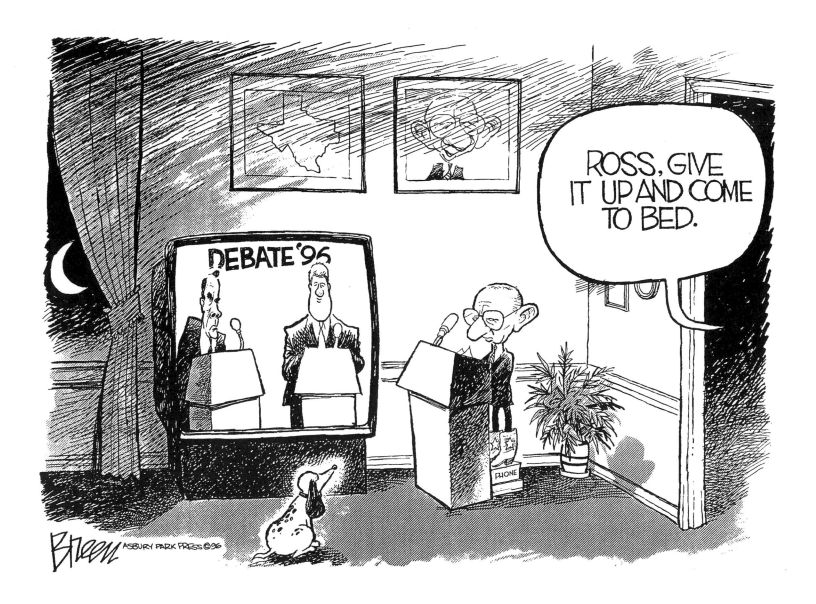

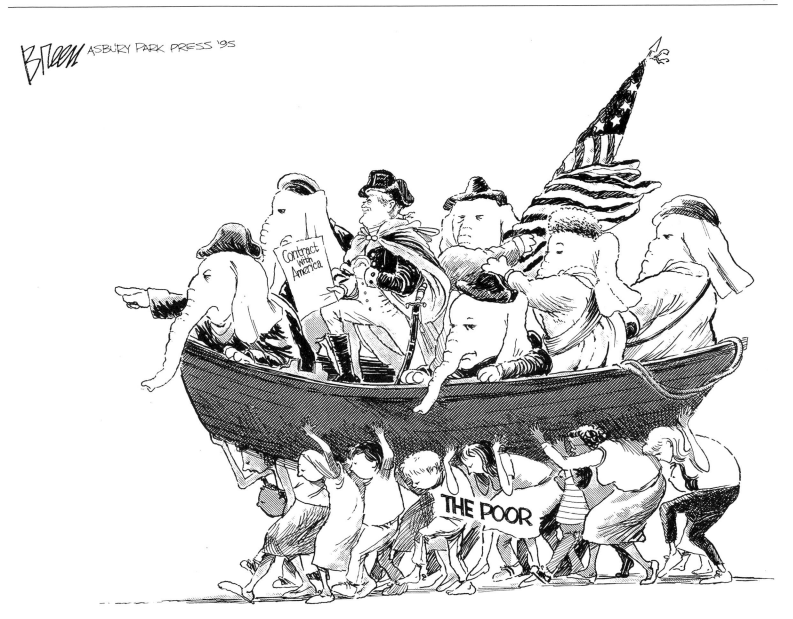

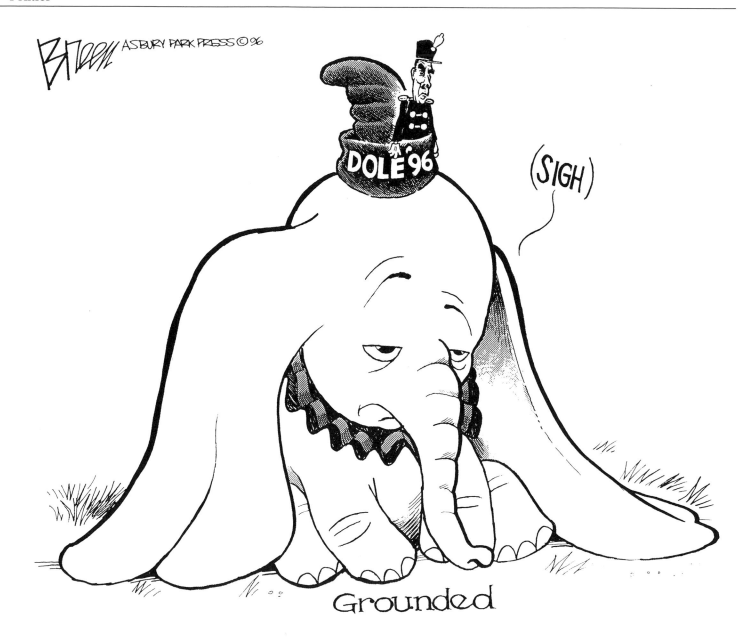

Grounded

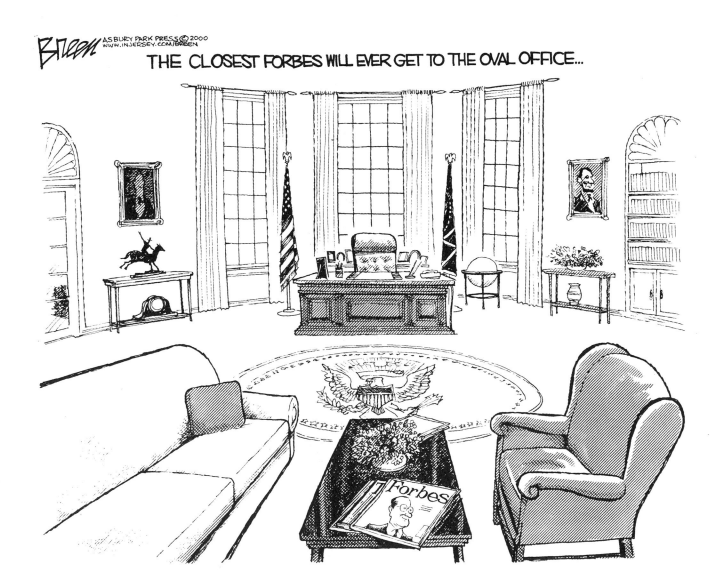

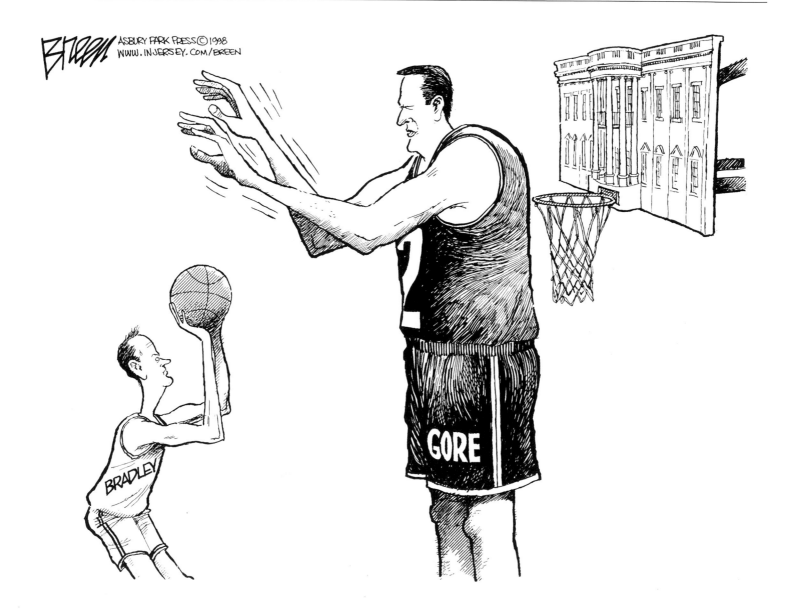

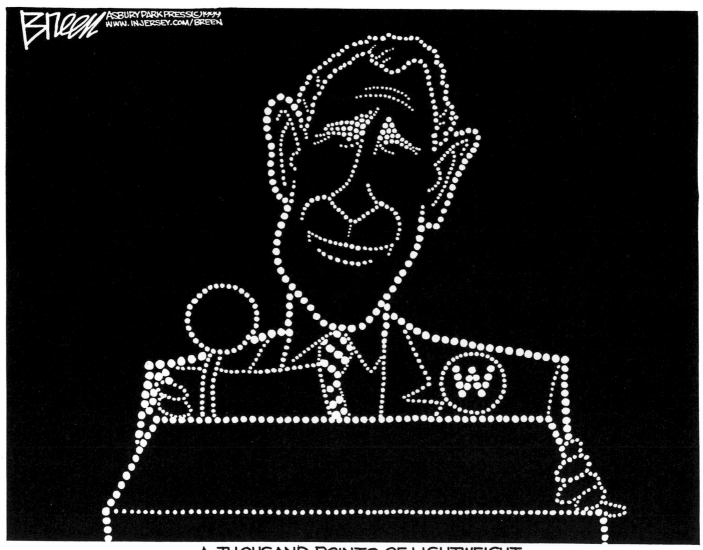

A THOUSAND POINTS OF LIGHTWEIGHT

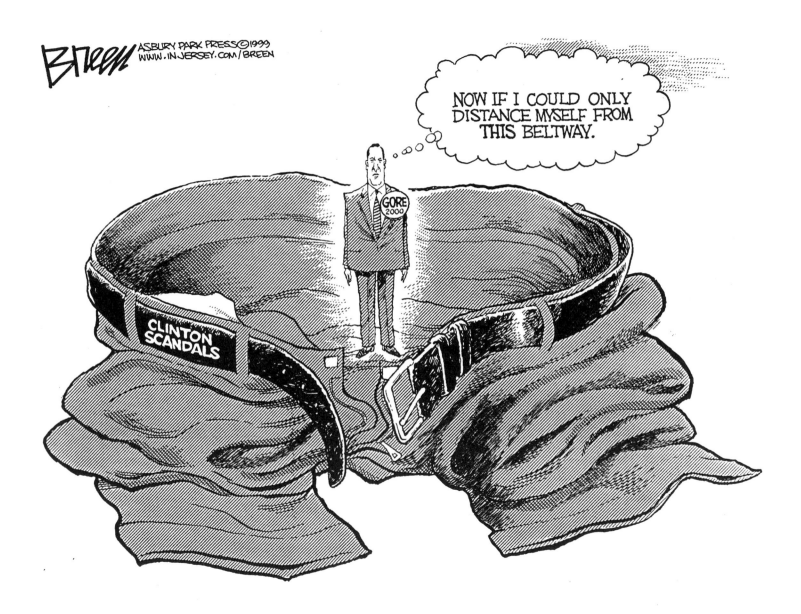

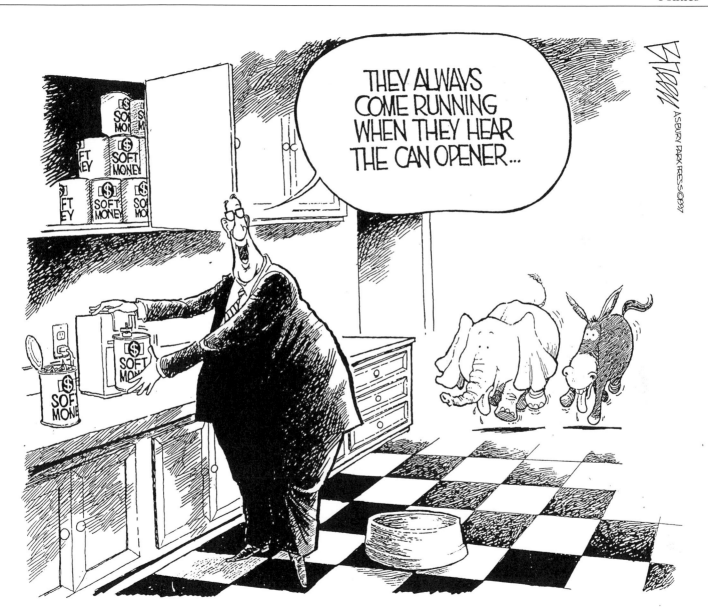

People Are Strange

Personalities

They are always fair game. Seeking the public spotlight, the famous and infamous often find themselves facing the unwanted glare of the editorial page. The following are just a few of my favorites. The more colorful the personality, the easier my job is.

Michael Jackson becoming a father. Ellen coming out of the closet. Dr. Kevorkian "assisting" people. Many of these cartoons wrote themselves. Some celebrities fared better than others. But, hey, that's show biz.

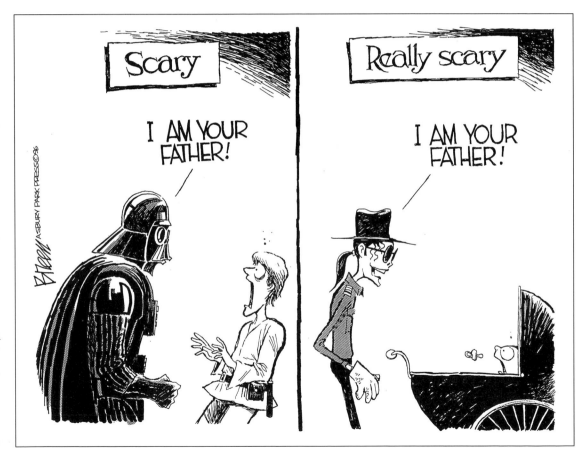

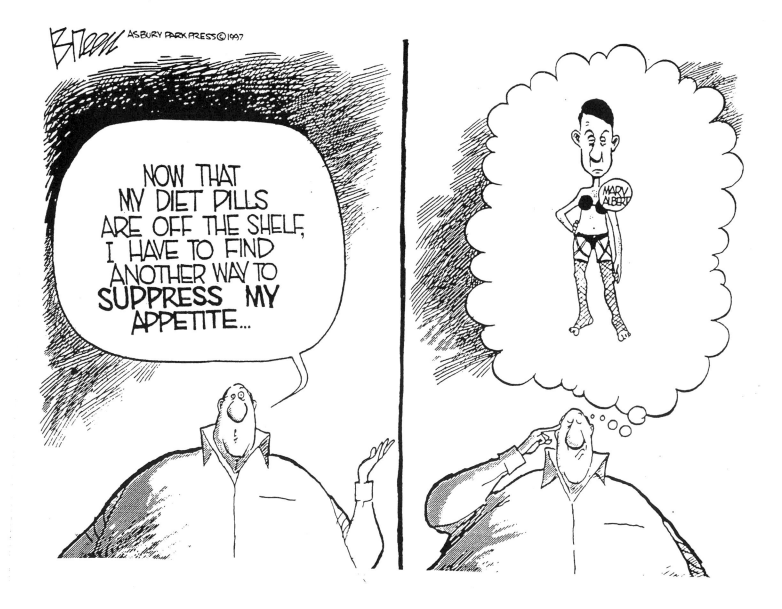

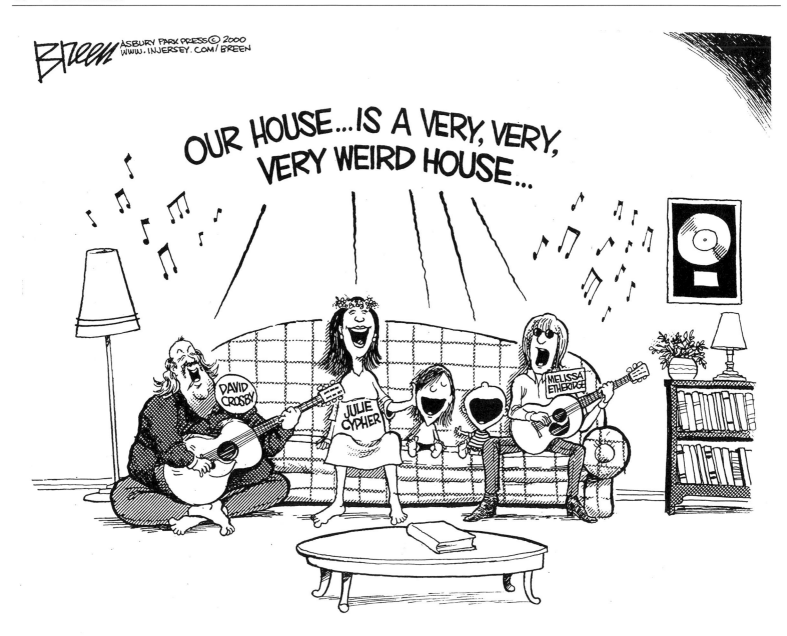

Which 'Seinfeld' character *will* **NBC** miss the most?

A) Jerry

B) Elaine

C) Kramer

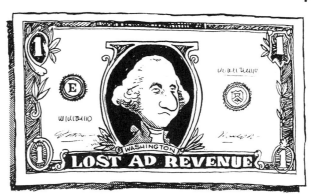

WASHINGTON

LOST AD REVENUE

D) George

ASBURY PARK PRESS © 1998

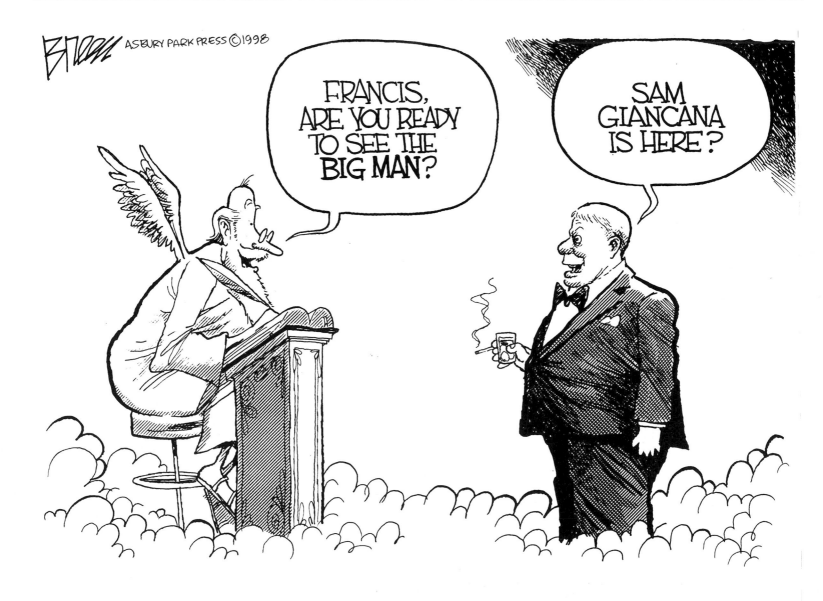

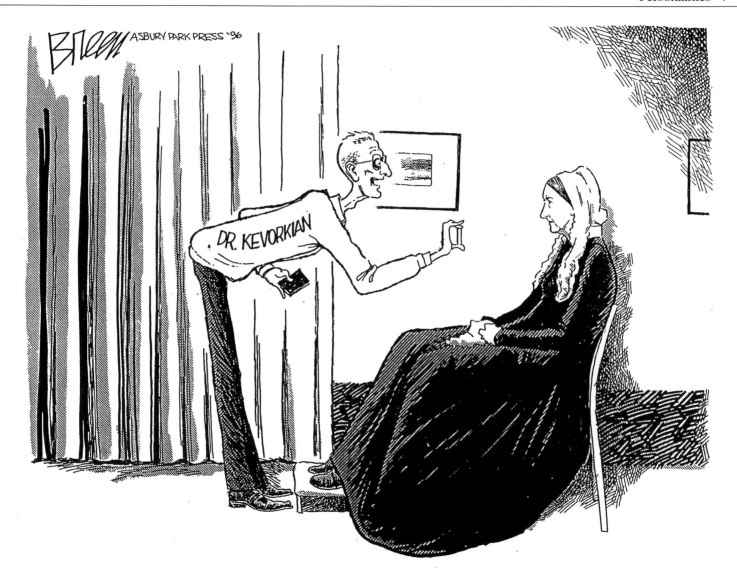

" MY CARD... "

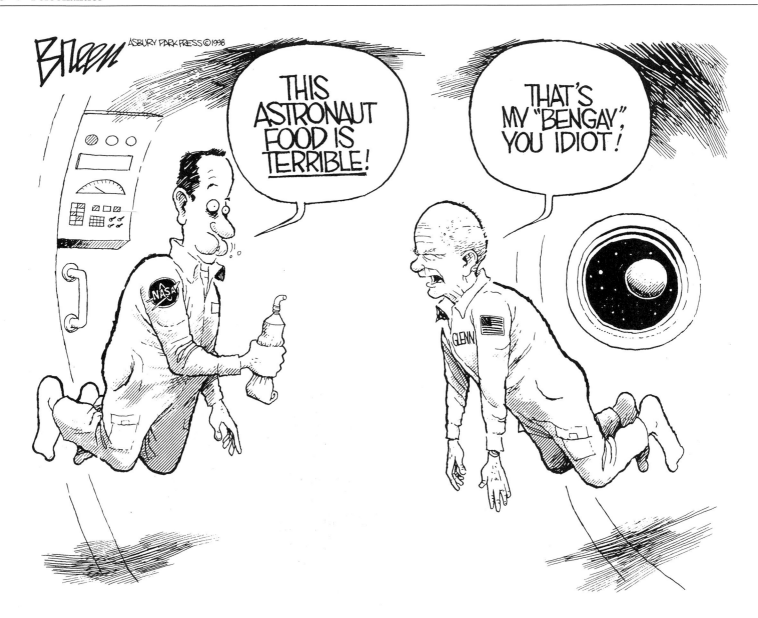

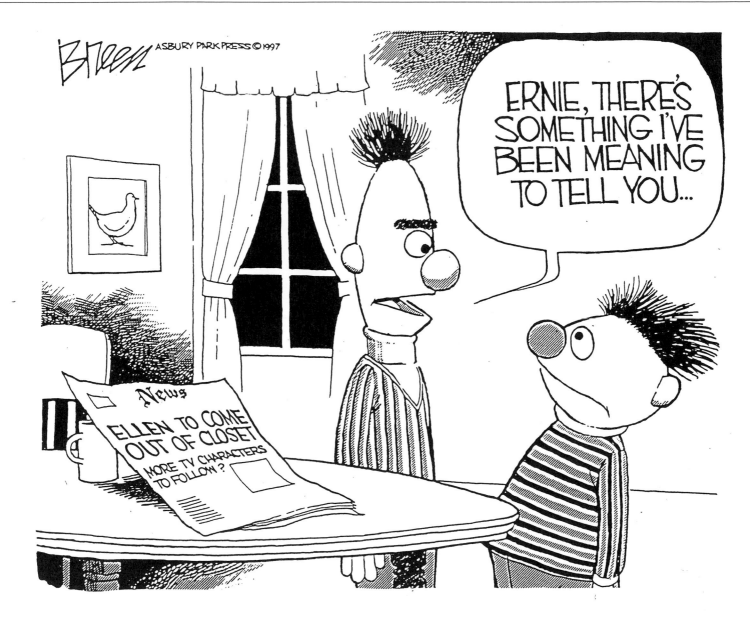

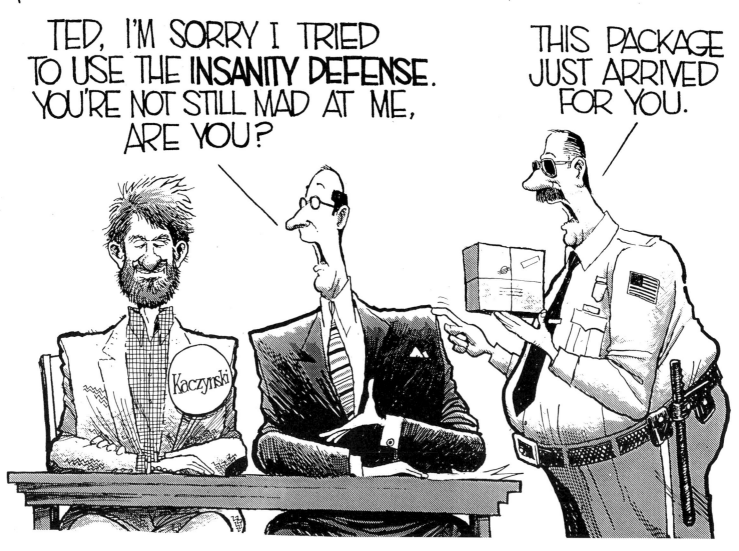

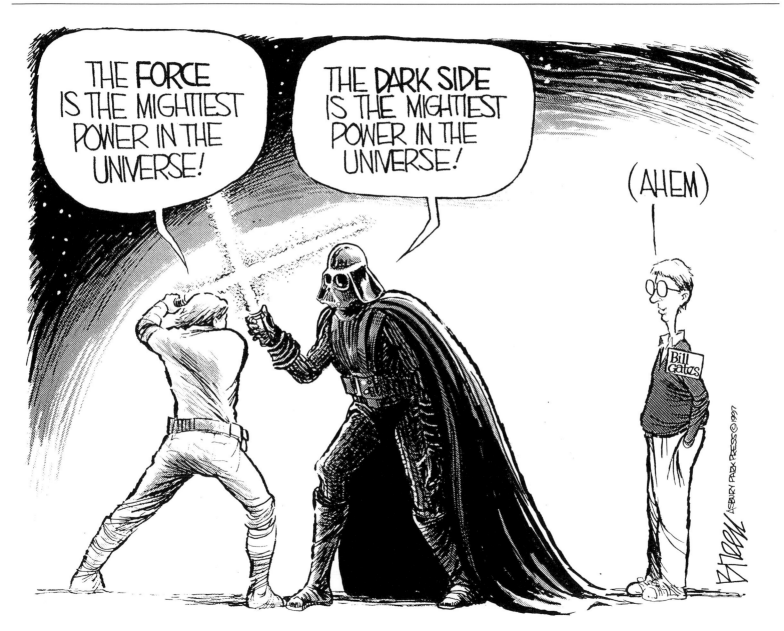

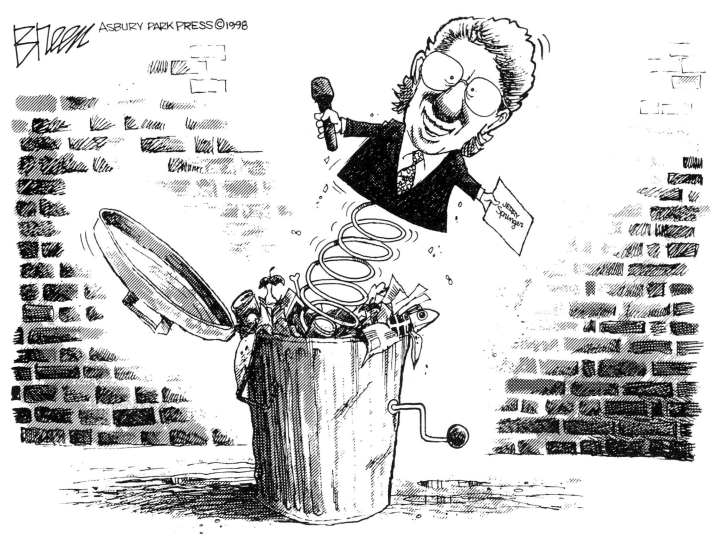

SPRINGER

Business As Usual?

The Economy

Art and commerce have never been an easy mix. But as the economy boomed and the business world became more accessible to mainstream America, the imagery associated with finance became more recognizable.

Successful businessmen replaced rock stars as kids' idols, and annual reports became hot summer reading. Business seemed to become more fun. And if it's fun, I want to be involved. To those who think an editorial cartoon about the economy can't be interesting, I have only one thing to say: Bull.

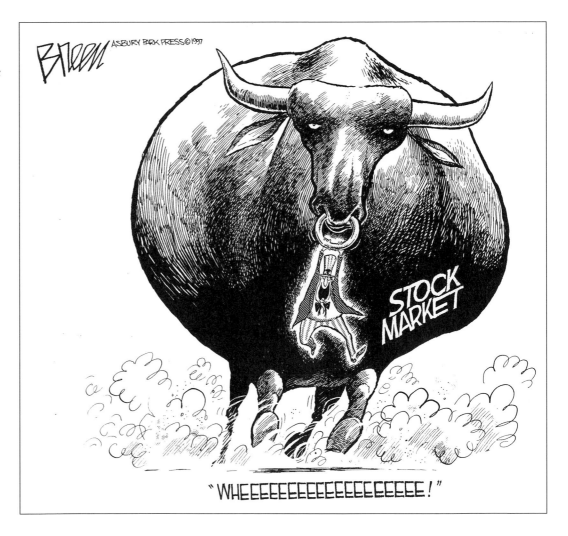

"WHEEEEEEEEEEEEEEEEEEEEE!"

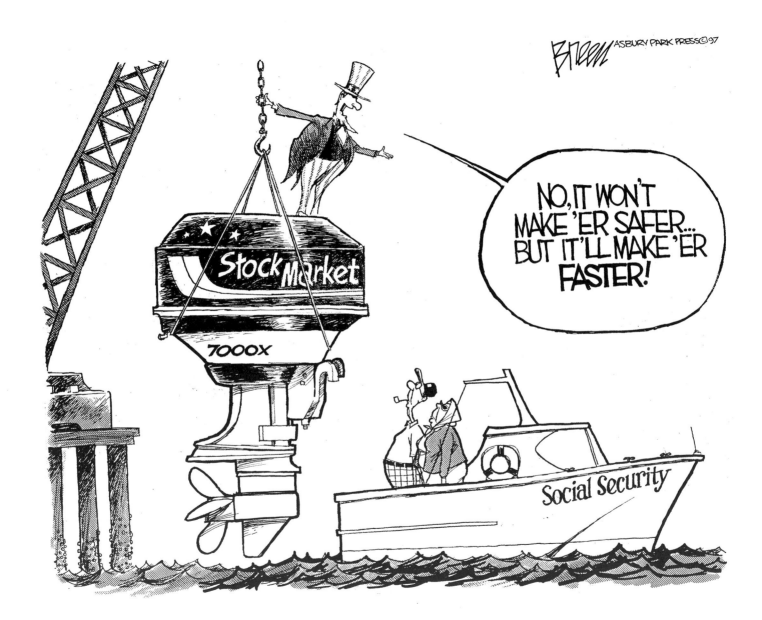

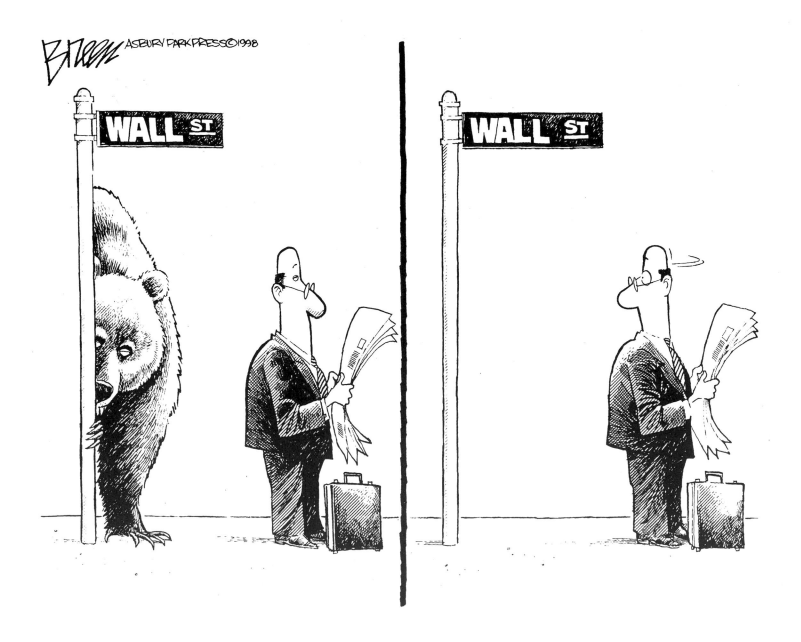

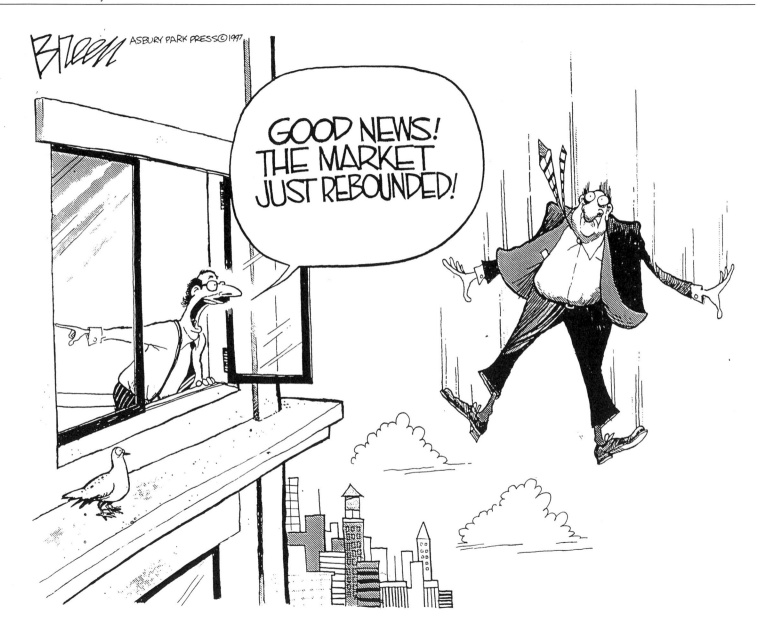

YEARS AGO, MAN THOUGHT EVERYTHING REVOLVED AROUND THE <u>EARTH</u>...

AS TIME PROGRESSED, HE LEARNED EVERYTHING REVOLVED AROUND THE <u>SUN</u>...

THEN, AS MORE TIME PROGRESSED...

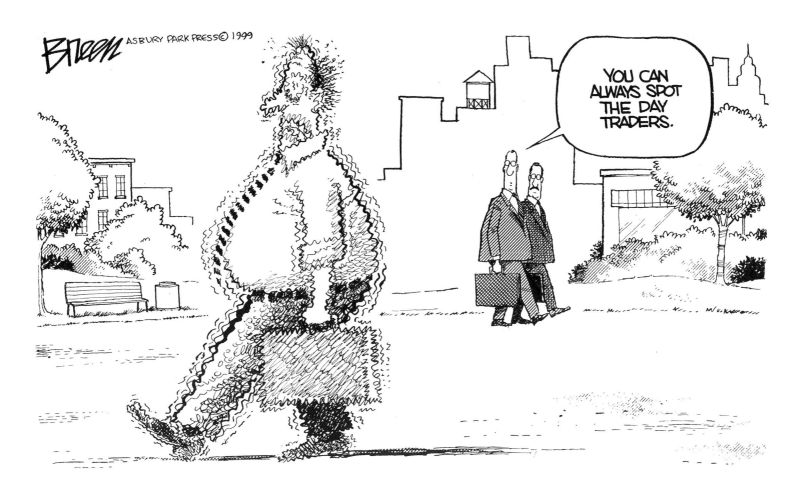

BREEN ASBURY PARK PRESS©1999
WWW.INJERSEY.COM/BREEN

MONOPOLY® GAME PIECES

Microsoft

NEW!

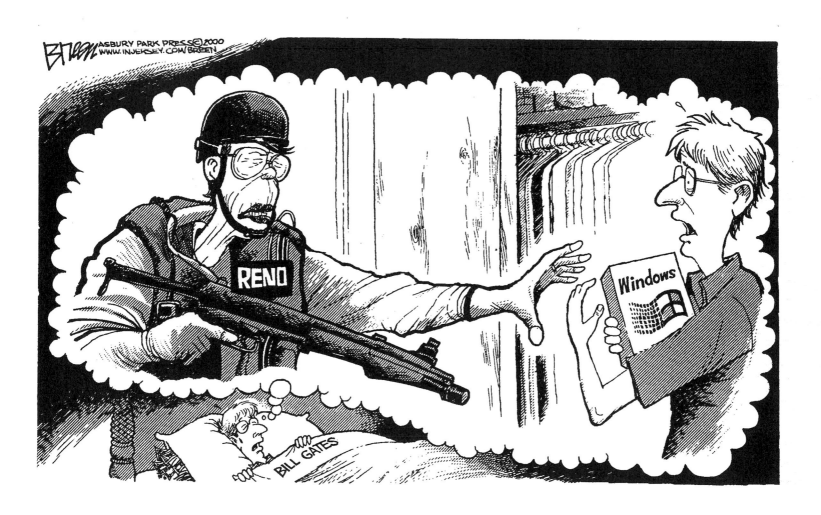

Sharply Drawn Opinions

Issues

Like everyone else in the U.S., I have the luxury of expressing my own opinion.

However, I'm fortunate in that I have the very public platform of a daily newspaper's editorial page to express myself. I try to touch upon subjects that I hope are important to everyone: the sanctity of life, safety for our families and equality for all. Not everyone agrees with me, but as another cartoonist said, "I don't aim to please, I just aim."

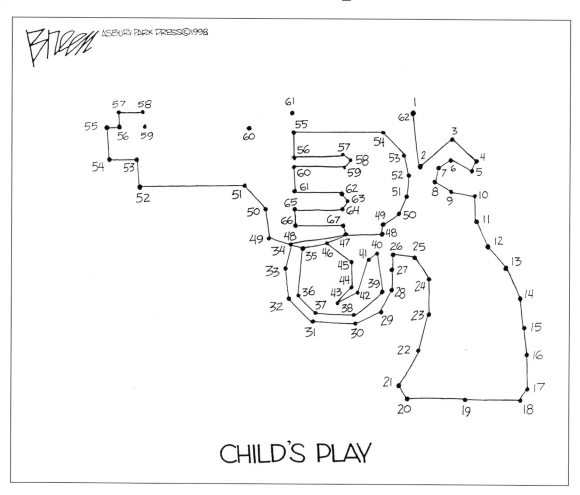

CHILD'S PLAY

NEW Crayon Colors

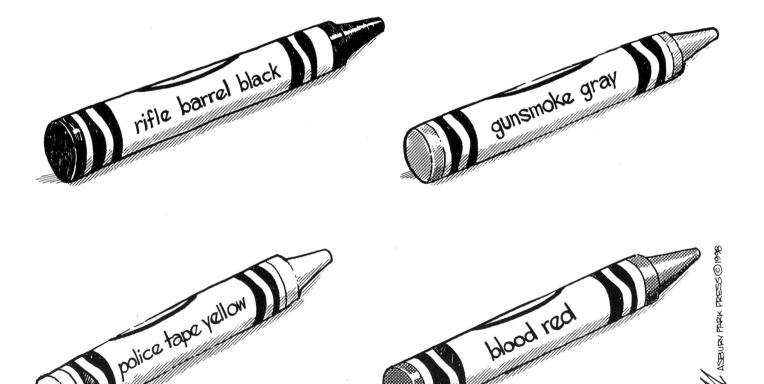

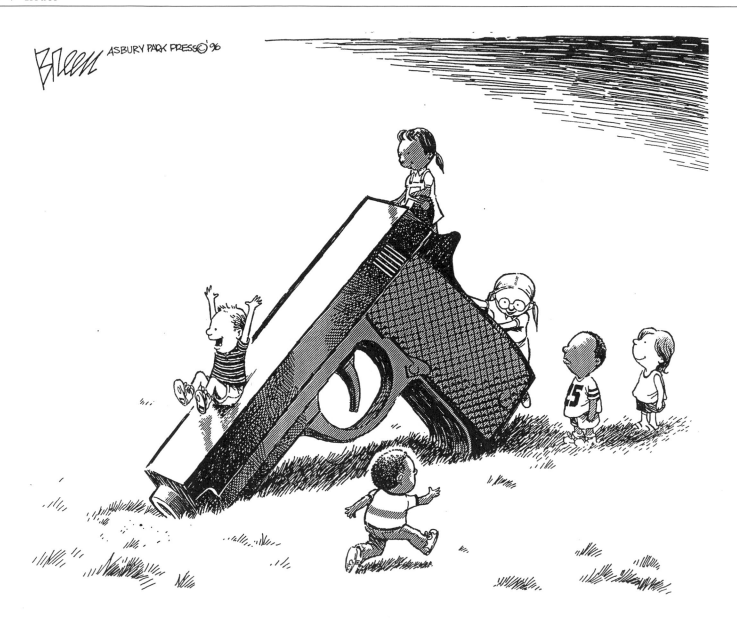

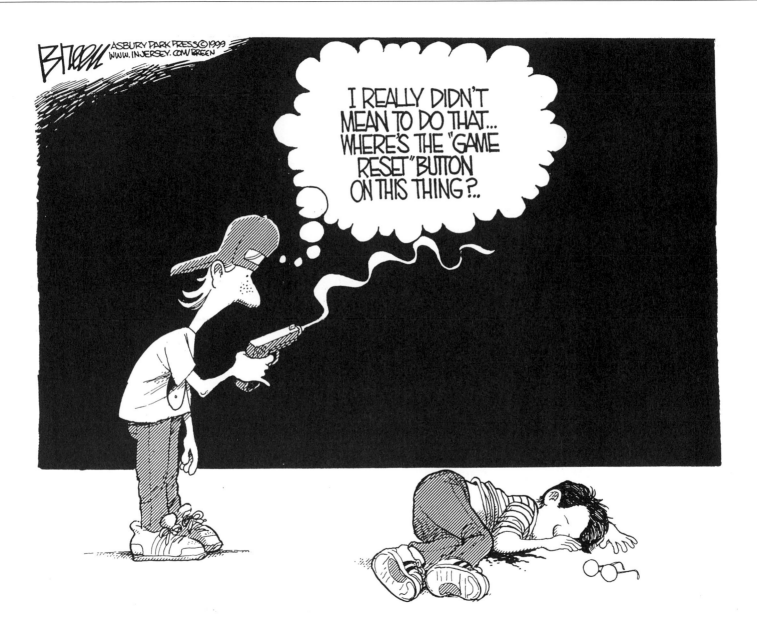

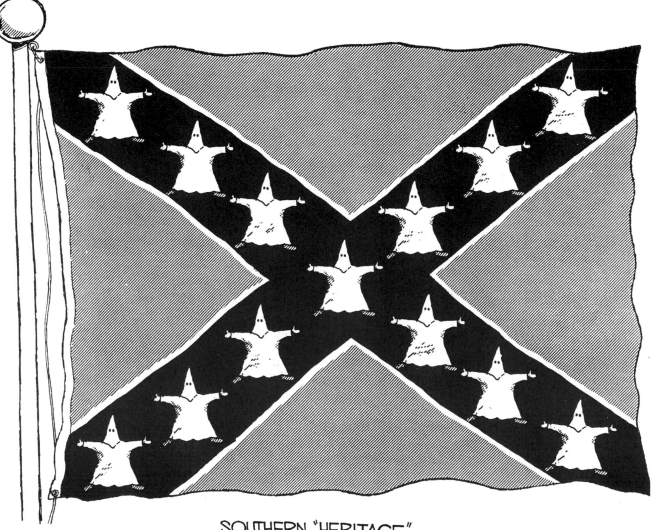

SOUTHERN "HERITAGE"

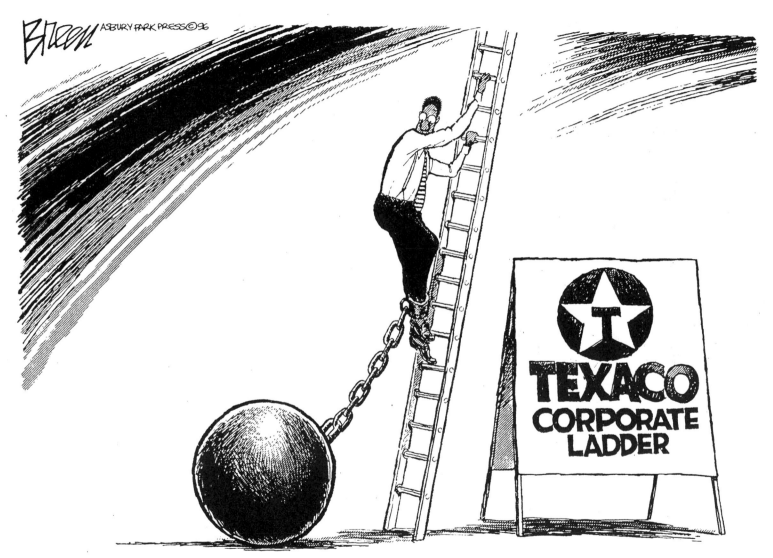

Leaded.

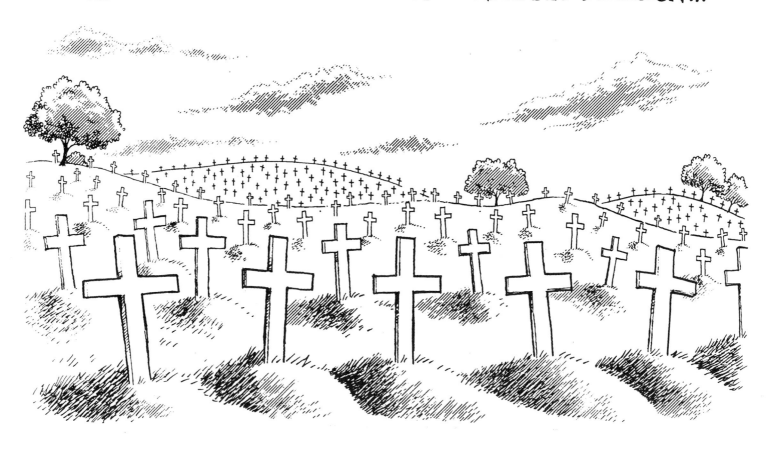

Q: How many Americans receive the death penalty each year despite their innocence?

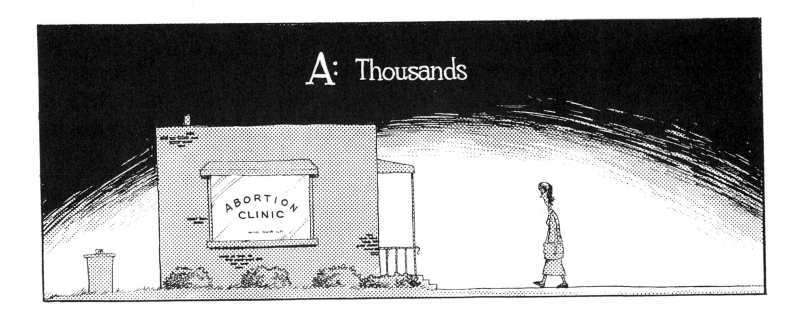

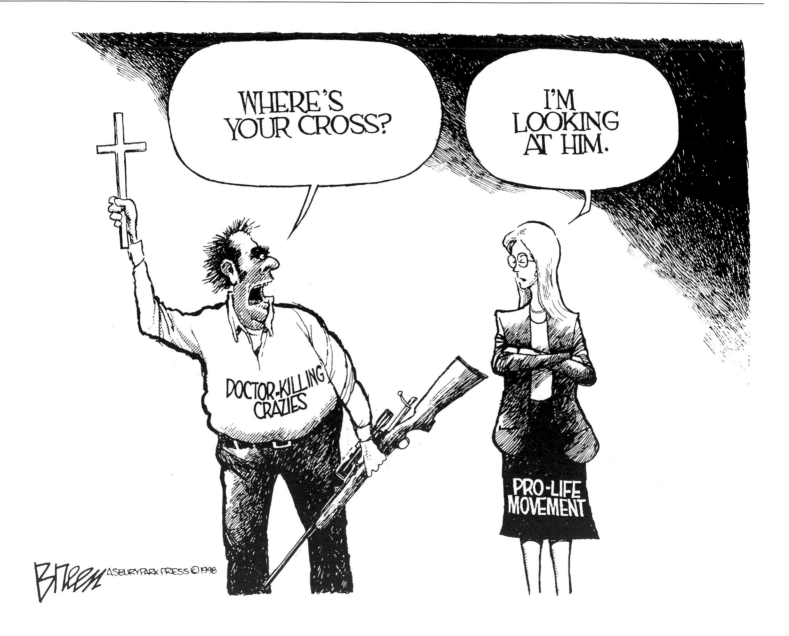

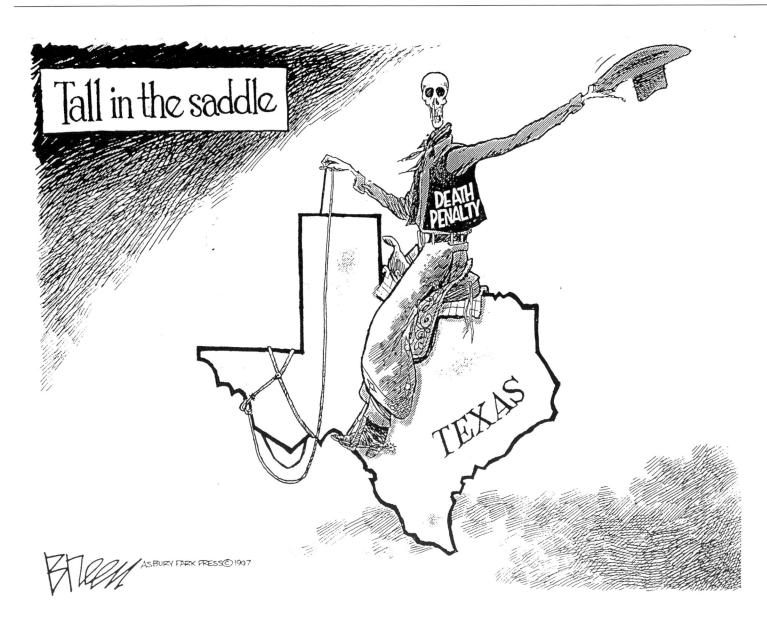

Tall in the saddle

DEATH PENALTY

TEXAS

ASBURY PARK PRESS© 1997

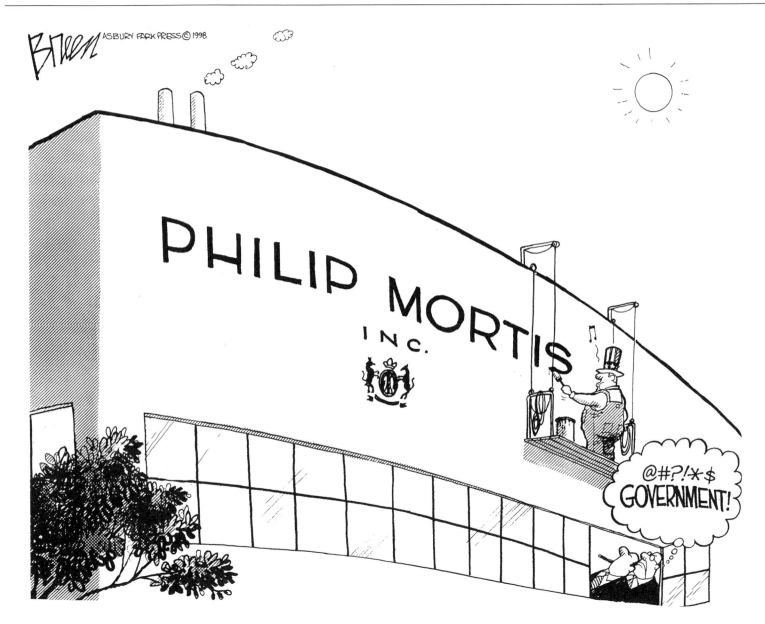

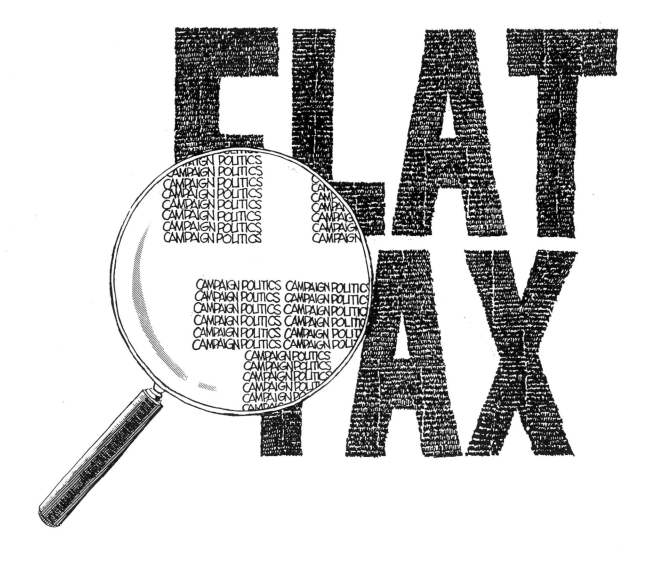

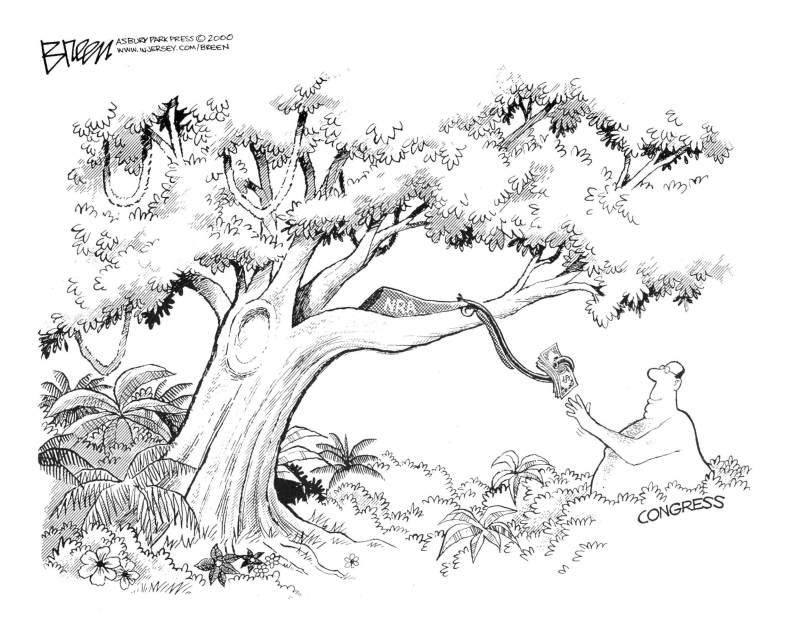

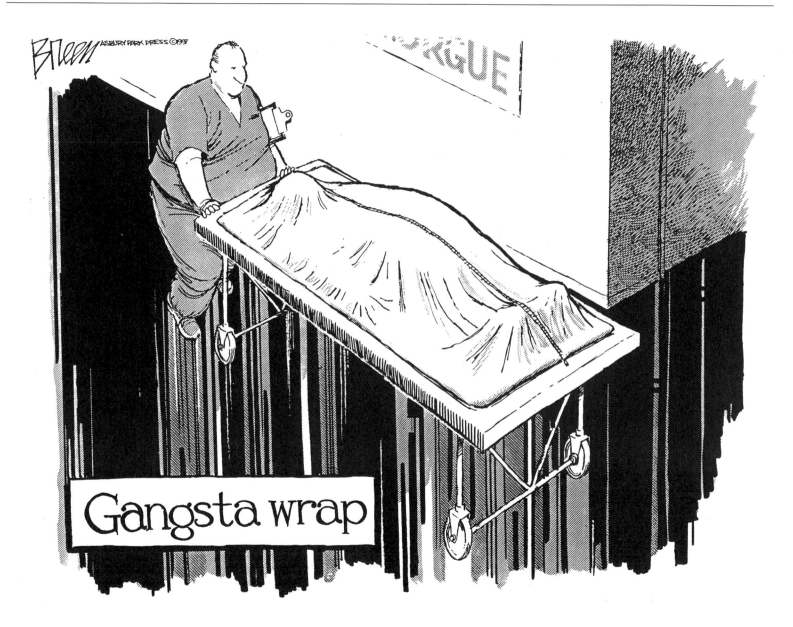

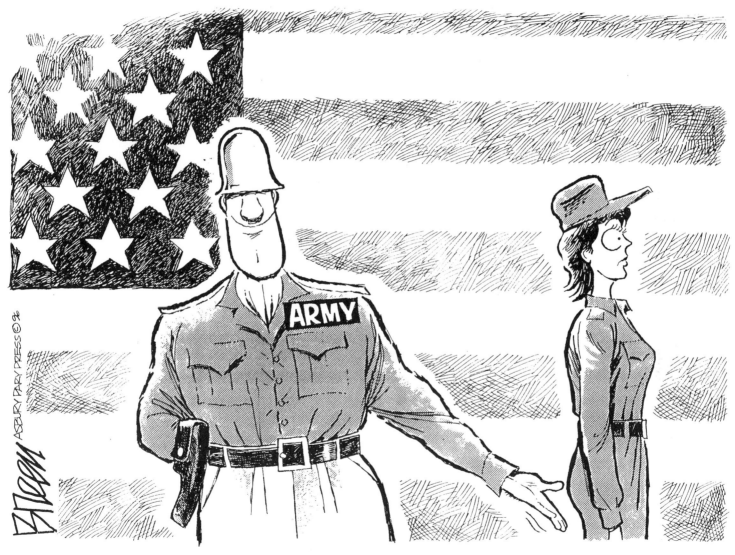

PATTIN'

America's Artland

Life in the USA

You can't make this stuff up. Well, I can, but that wouldn't be right. For inspiration, all I do is follow events and keep up with what's happening around the country.

Every day, I read four newspapers, watch the news and keep my eyes open for items of interest: something that speaks to where and how we live and gives my readers a moment to pause, to reflect and to laugh. It's a great job. Only in America.

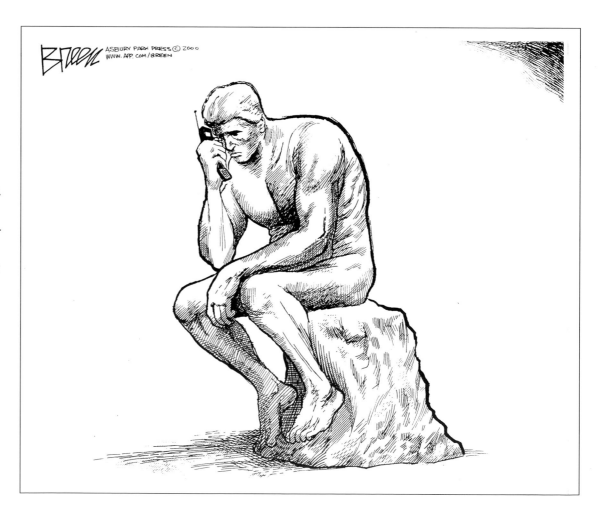

BREEN ASBURY PARK PRESS © 2000
WWW.APP.COM/BREEN

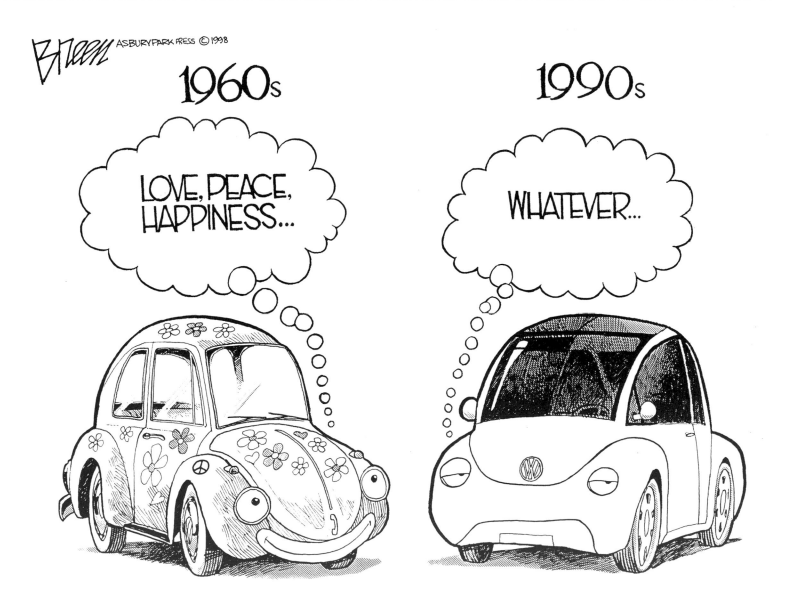

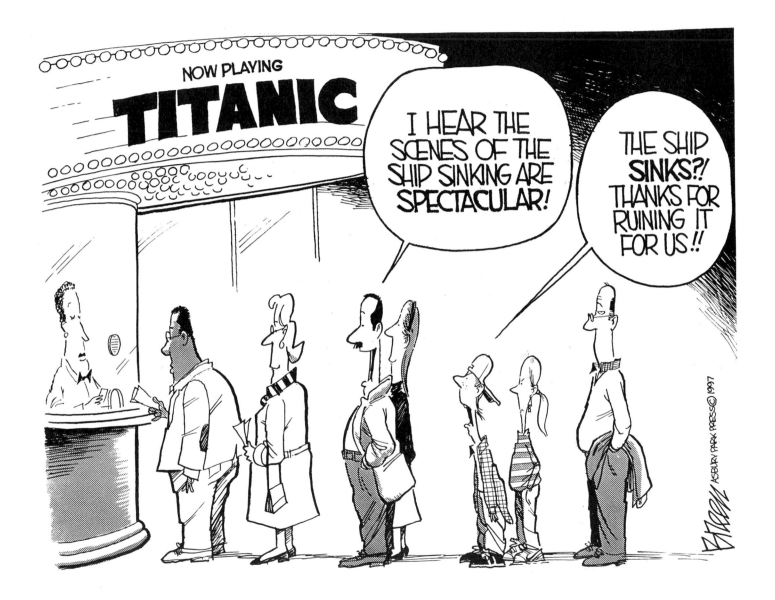

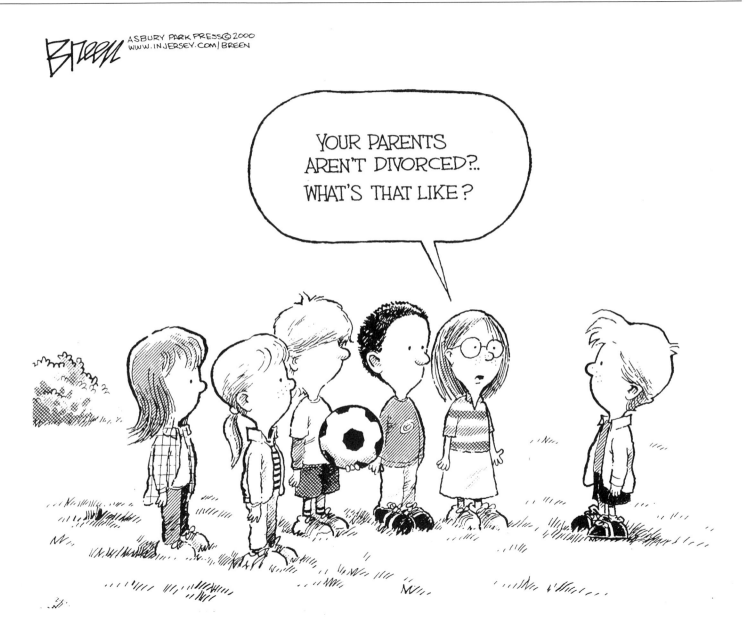

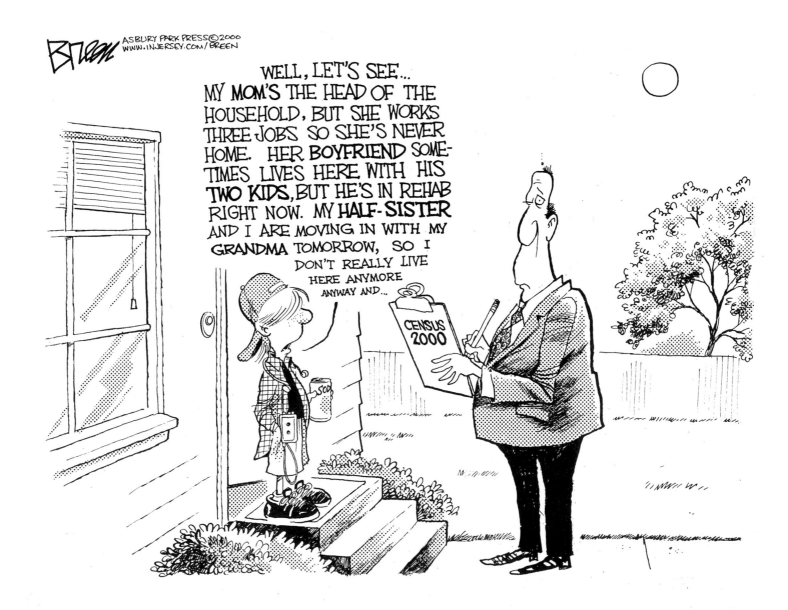

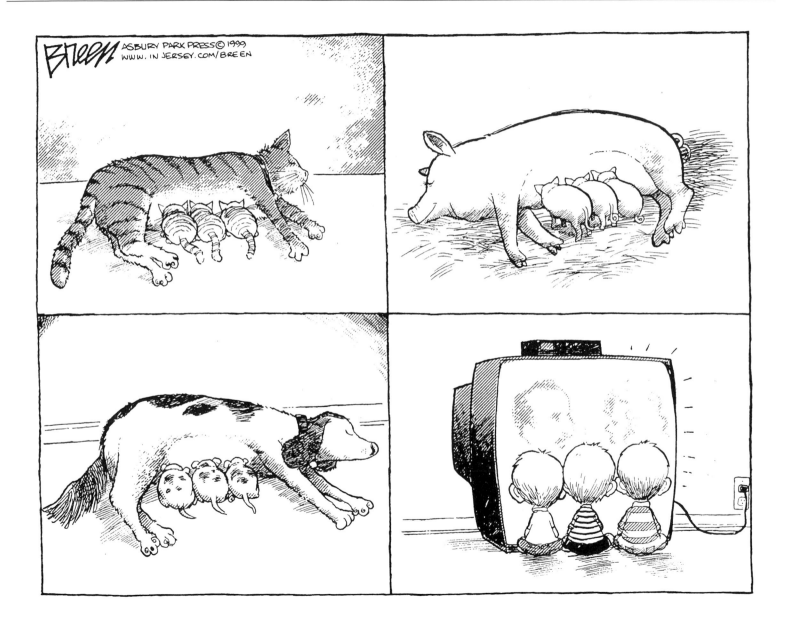

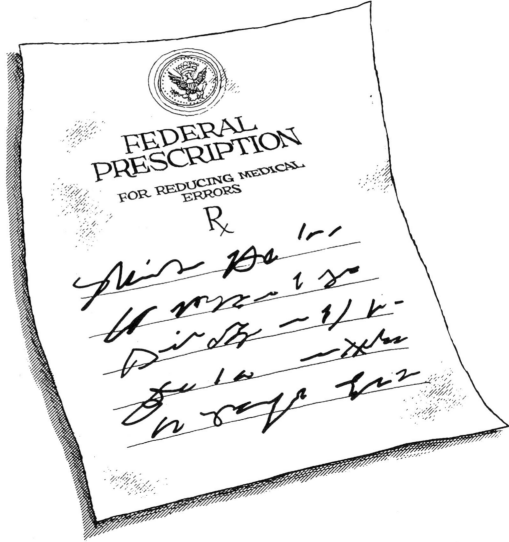

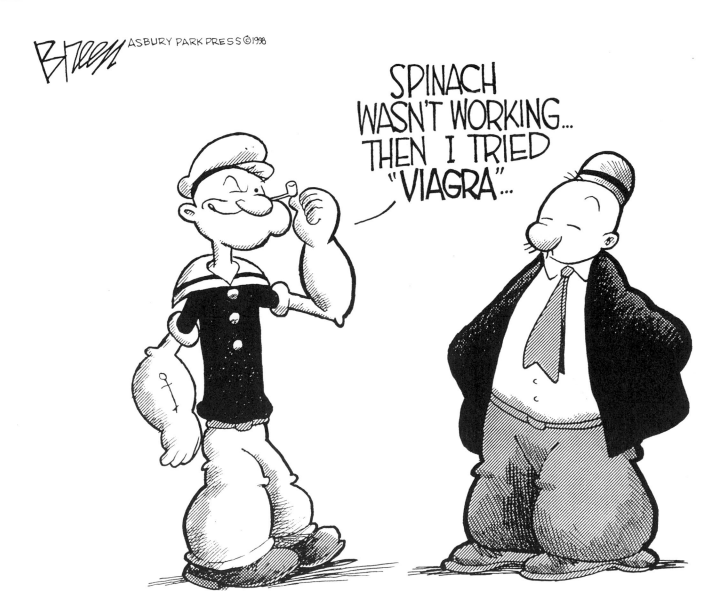

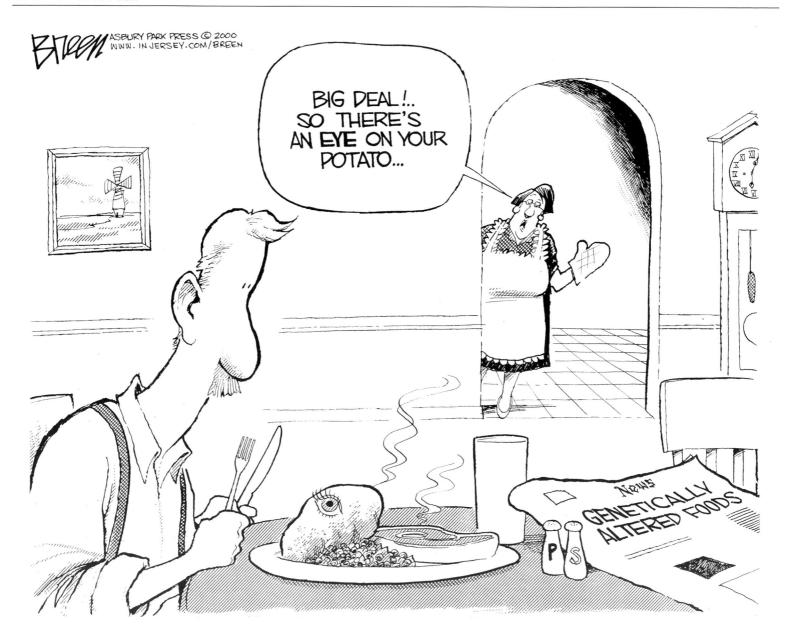

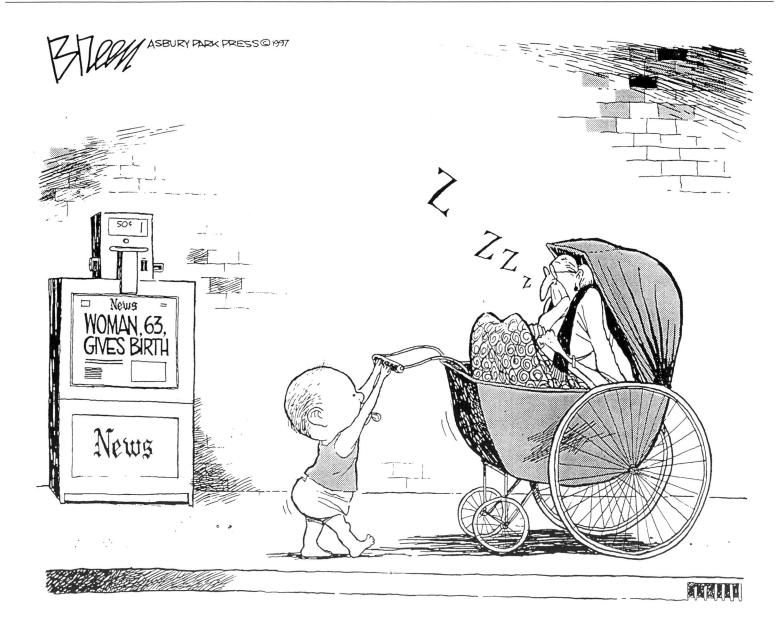

PERM AND DYE JOB

DENTAL WORK

RHINOPLASTY

MAKEUP AND GIRDLE

BREAST IMPLANTS

WE'LL PAY YOU $50,000 FOR YOUR EGGS!

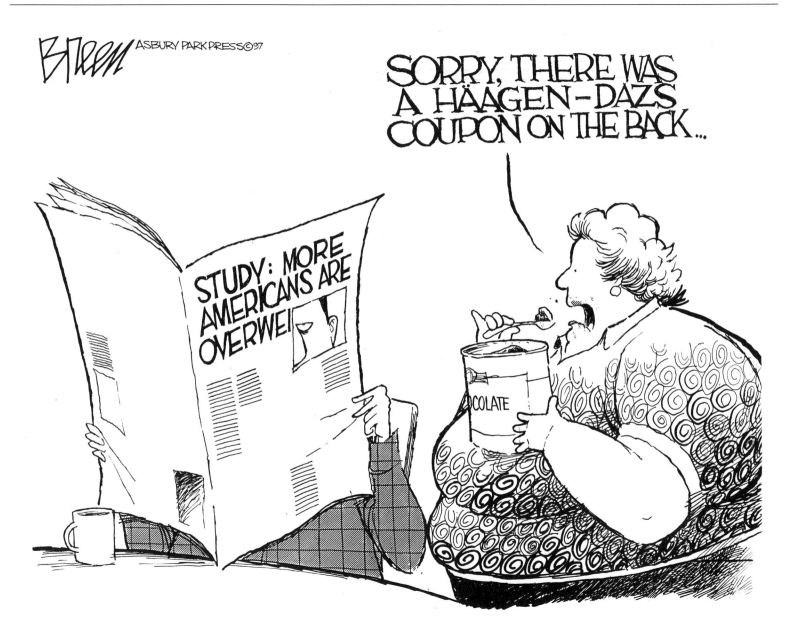

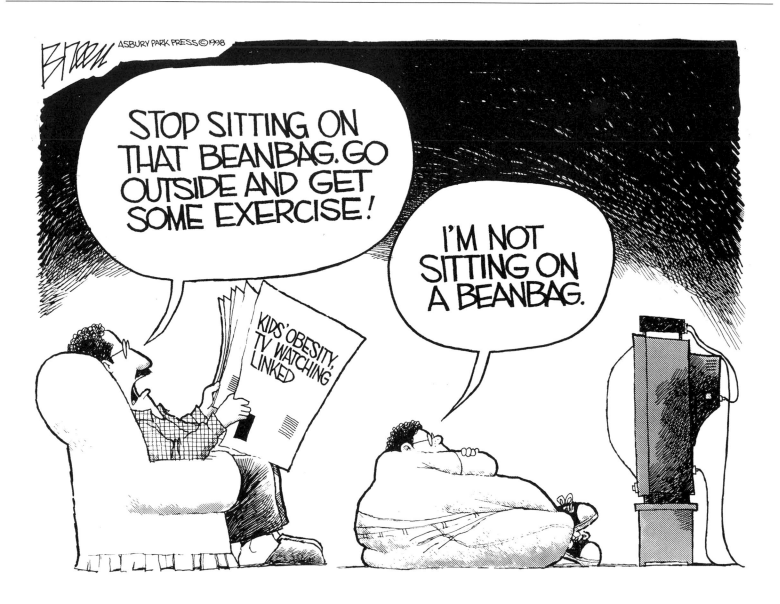

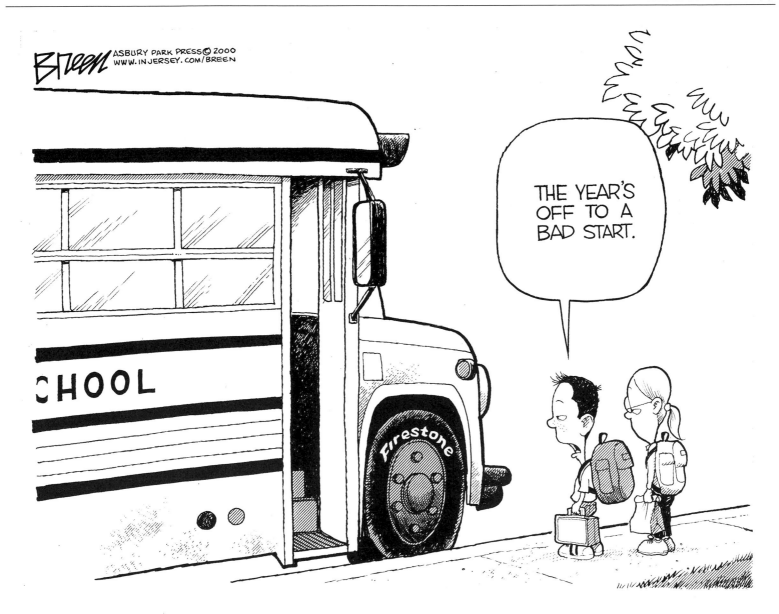

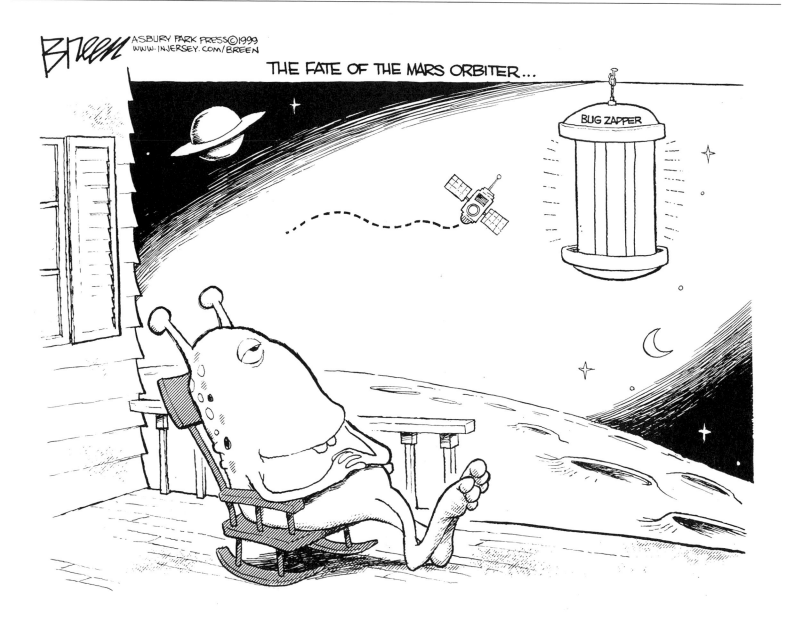

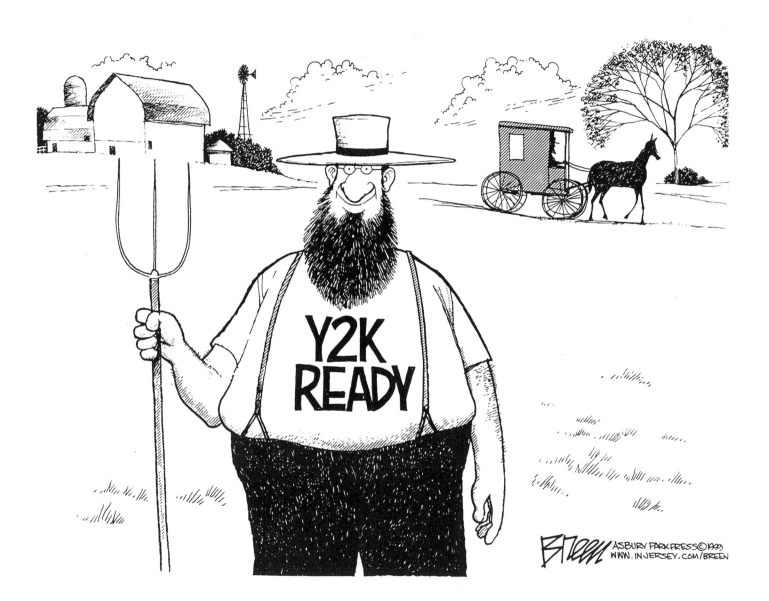

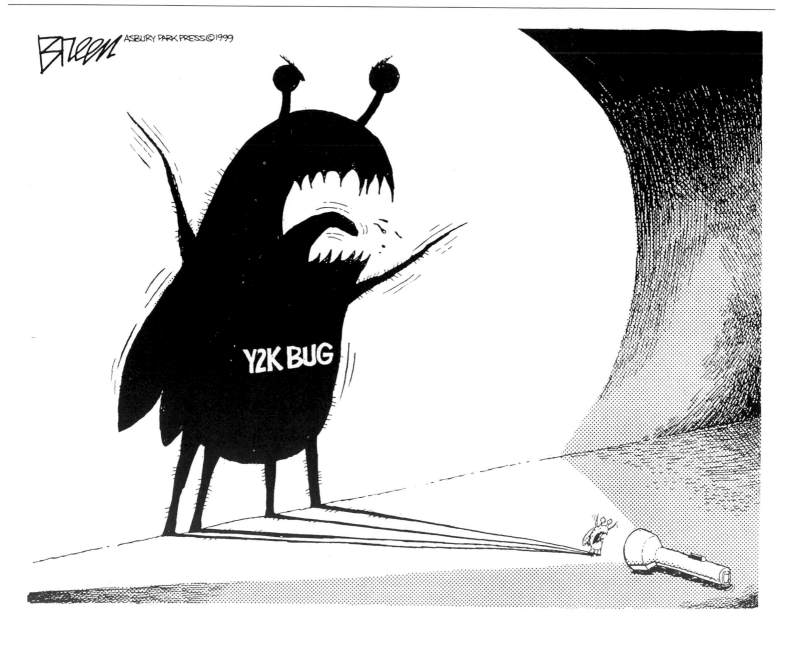

What Exit Are You From?

New Jersey

New Jersey's been very good to me. I met my wife here. I got my start at the Asbury Park Press in Neptune. I've made great friends. Between Bruce, the bennies, beach replenishment and Governor Whitman, New Jersey has provided me a wealth of material. I could do five cartoons a week exclusively on Jersey issues.

I've been fortunate enough to be made welcome here and given an opportunity to comment on, and yes, poke fun at, the uniqueness of the Garden State.

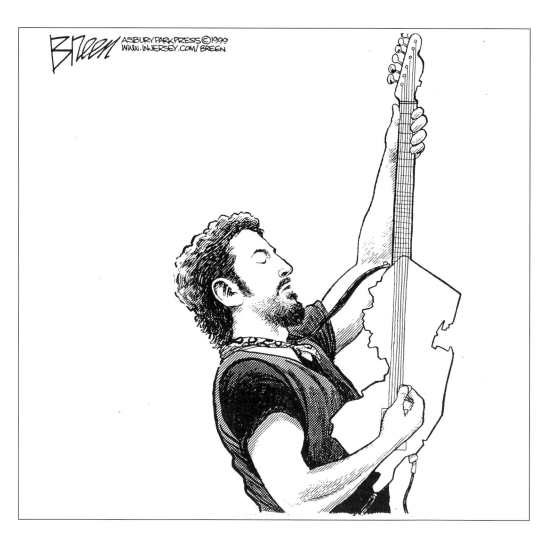

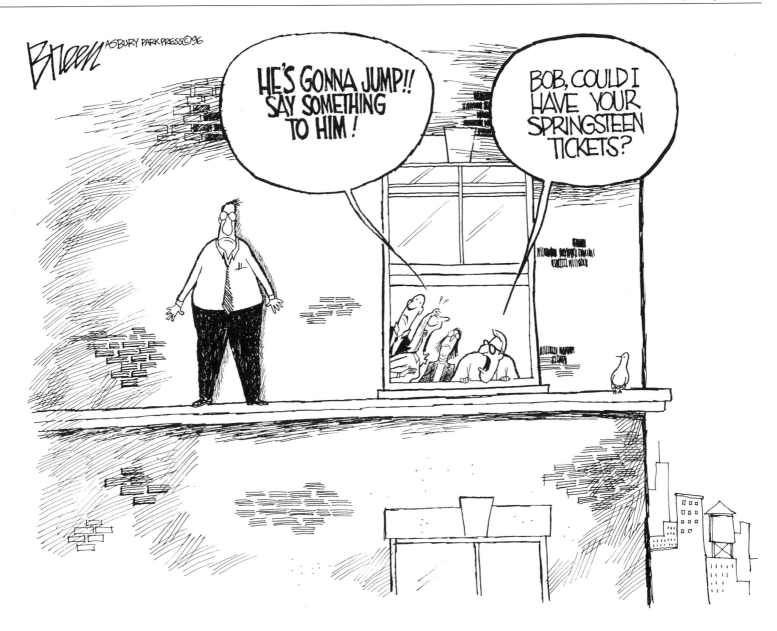

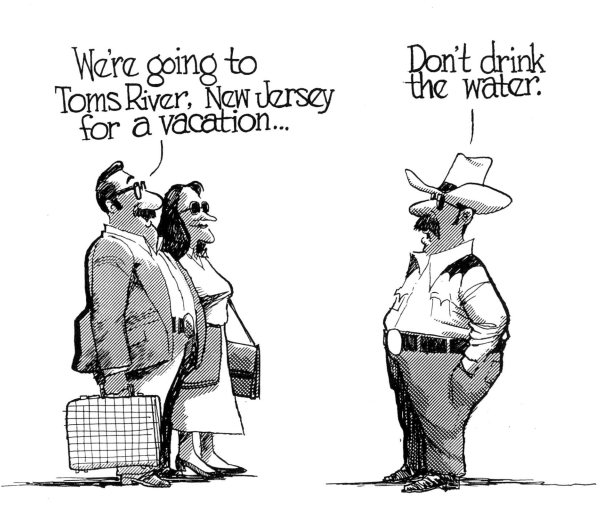

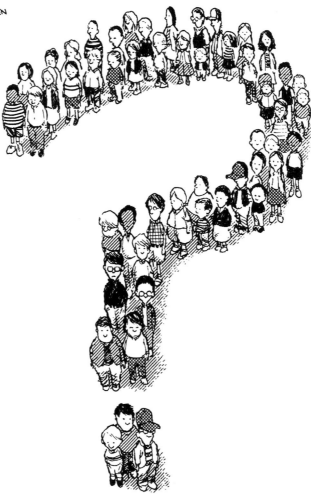

CANCER CLUSTER

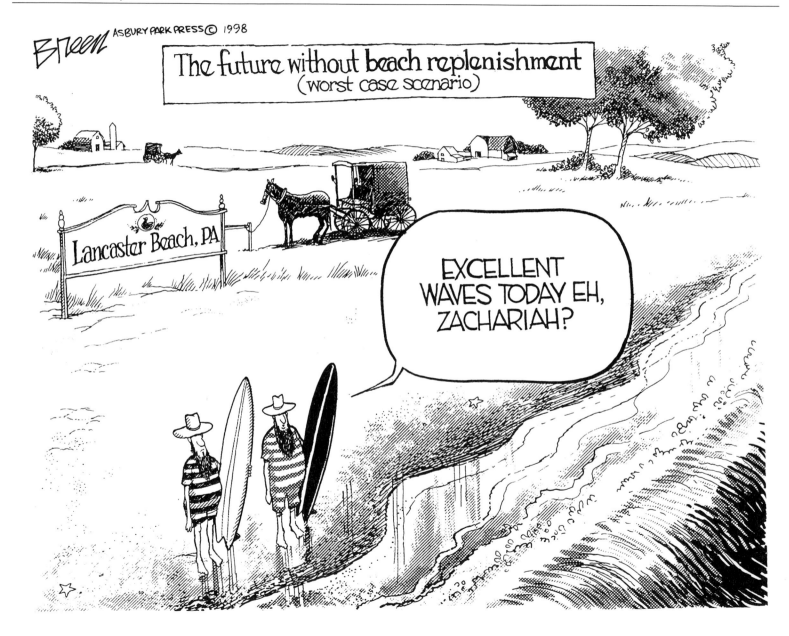

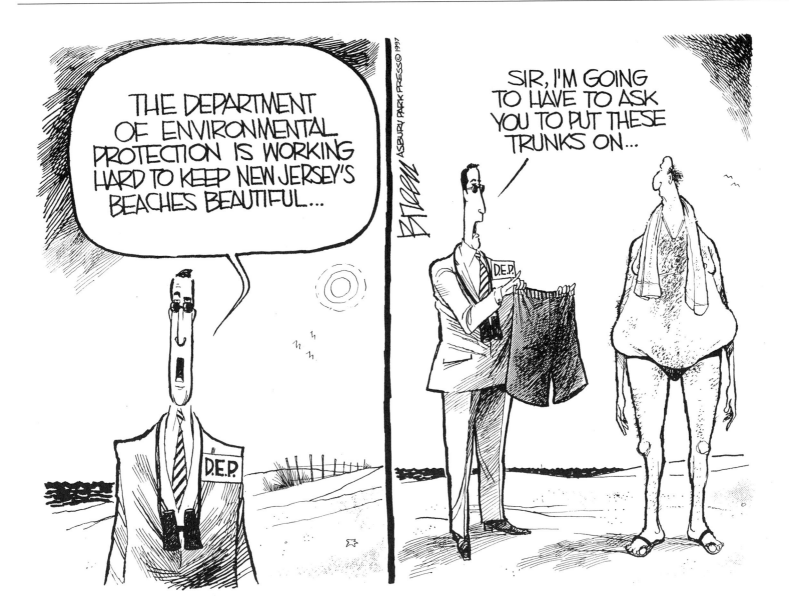

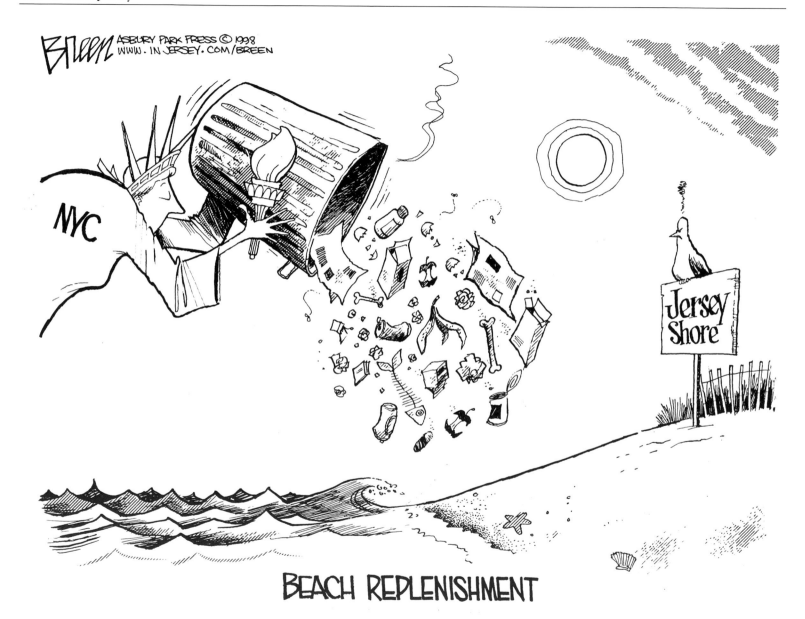

BEACH REPLENISHMENT

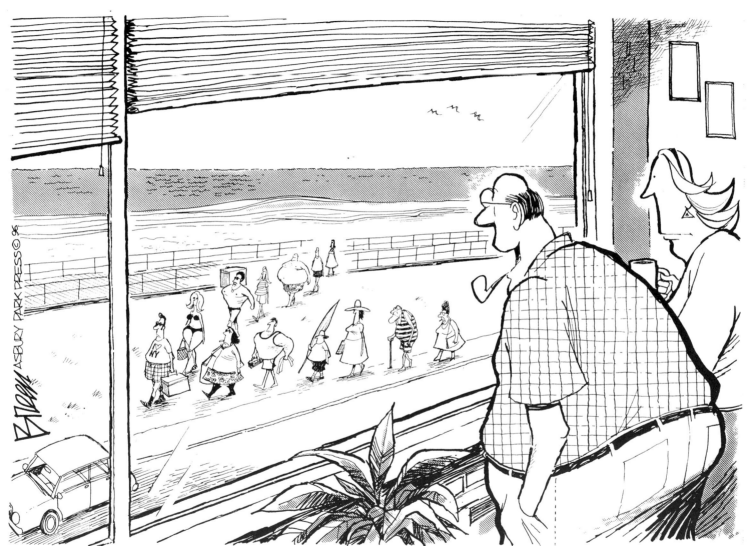

"Look, honey-a flock of bennies headed north for the winter."

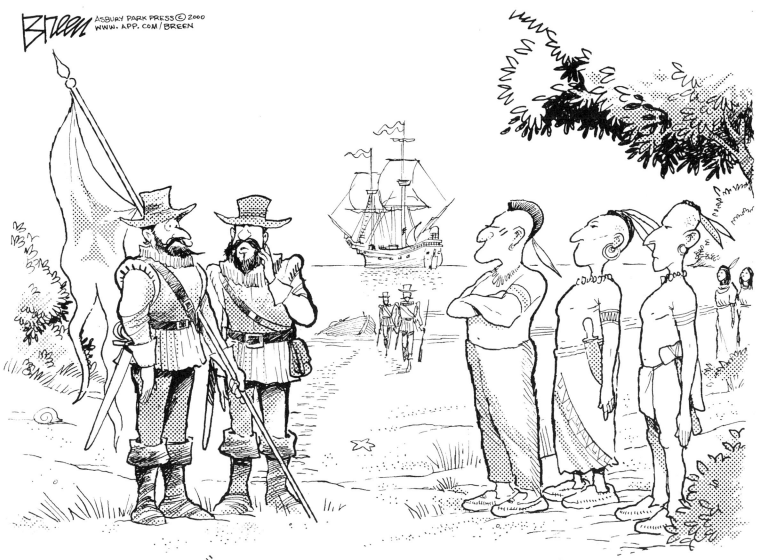

"THEY WANT TO SEE OUR BEACH BADGES"...

BREEN
ASBURY PARK PRESS © 1999
WWW.IN.JERSEY.COM/BREEN

STATE VANITY
PLATES...

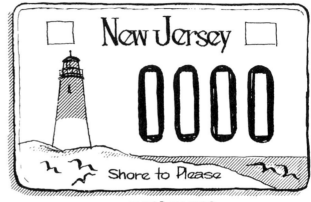

BEACHES

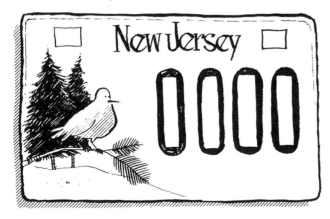

PINELANDS

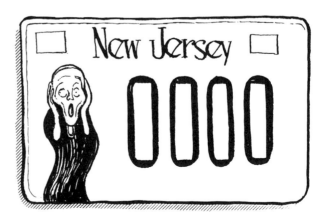

AUTO INSURANCE

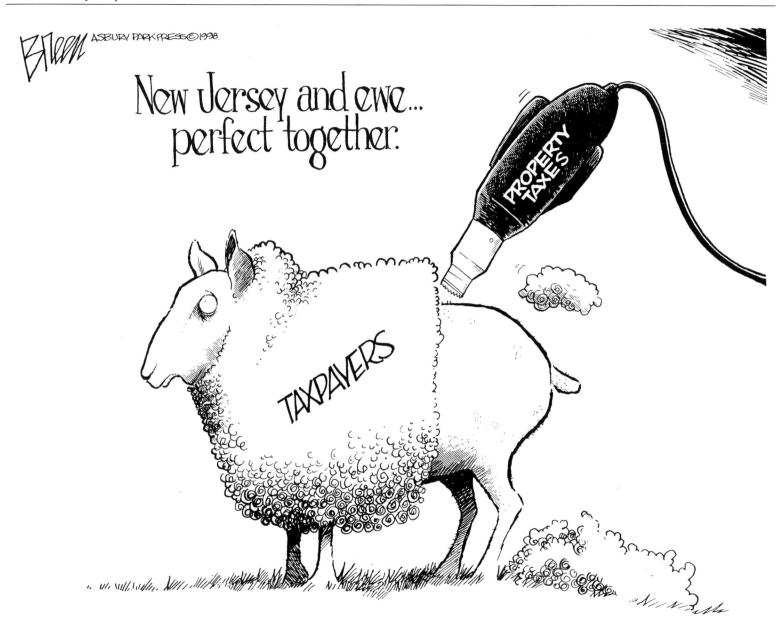

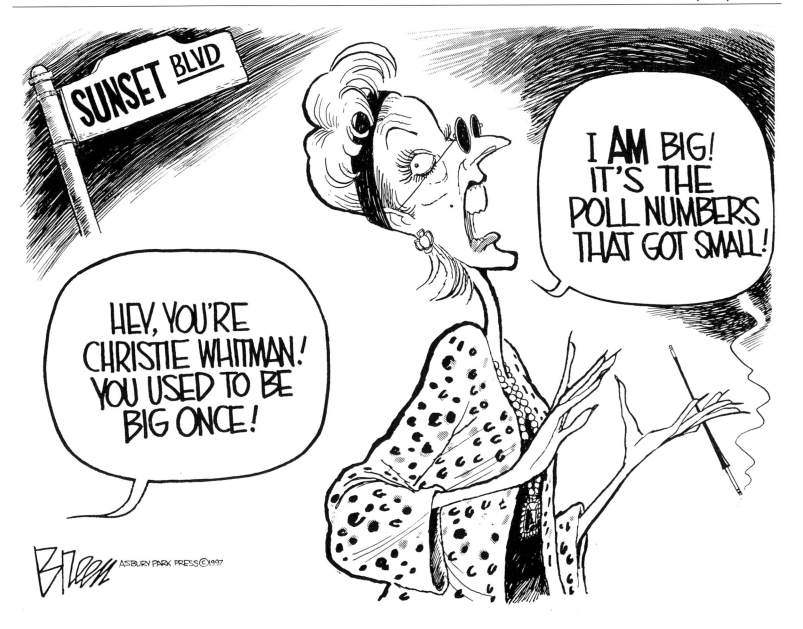

WHERE WE'RE HEADED...

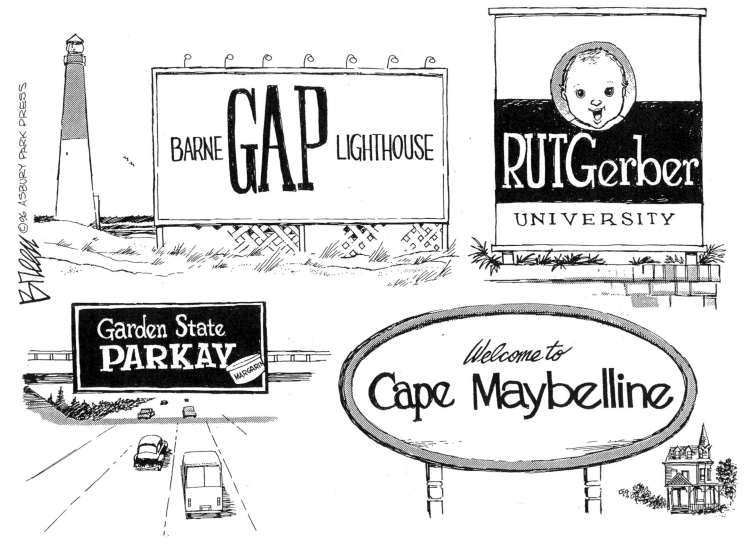

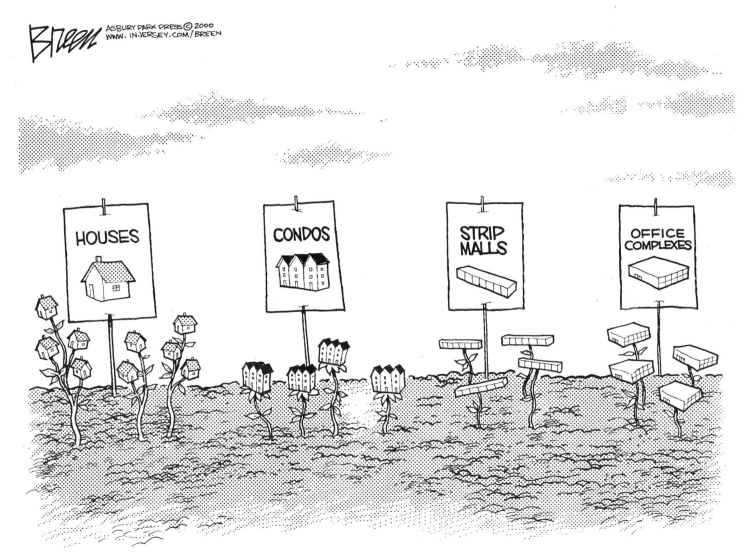

The Garden State

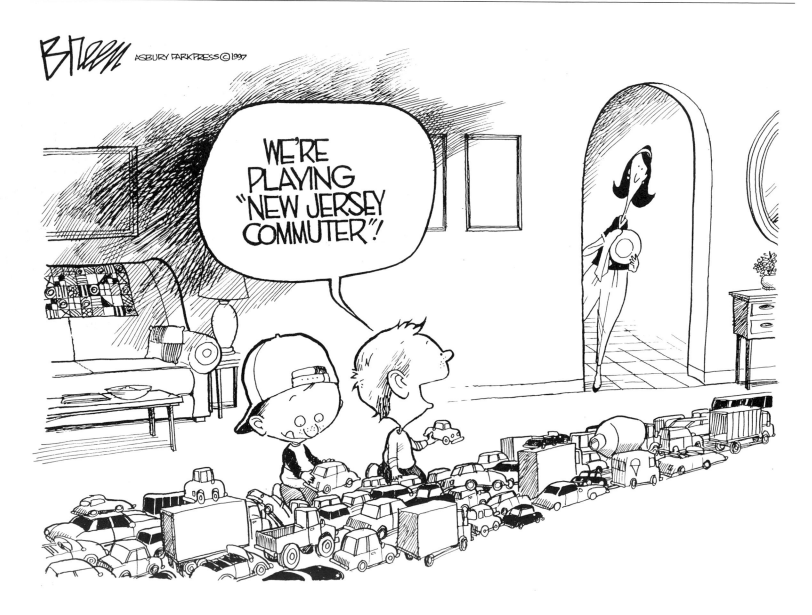

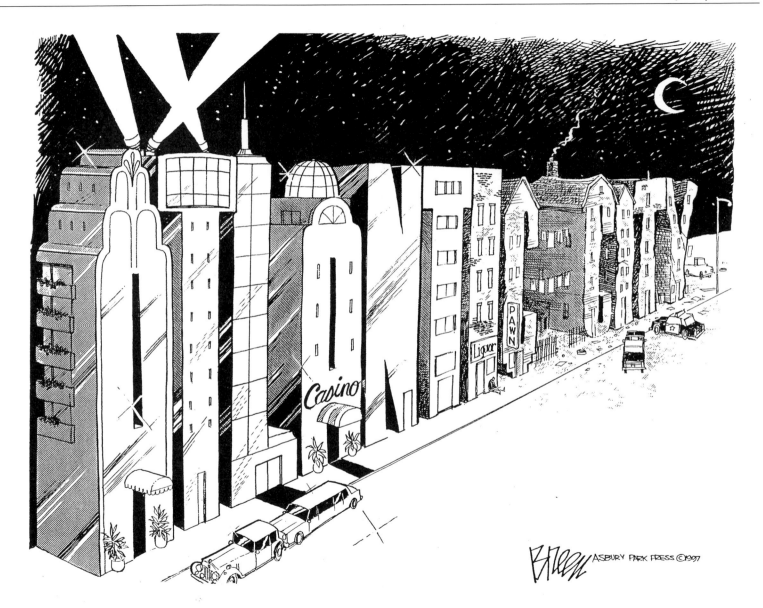

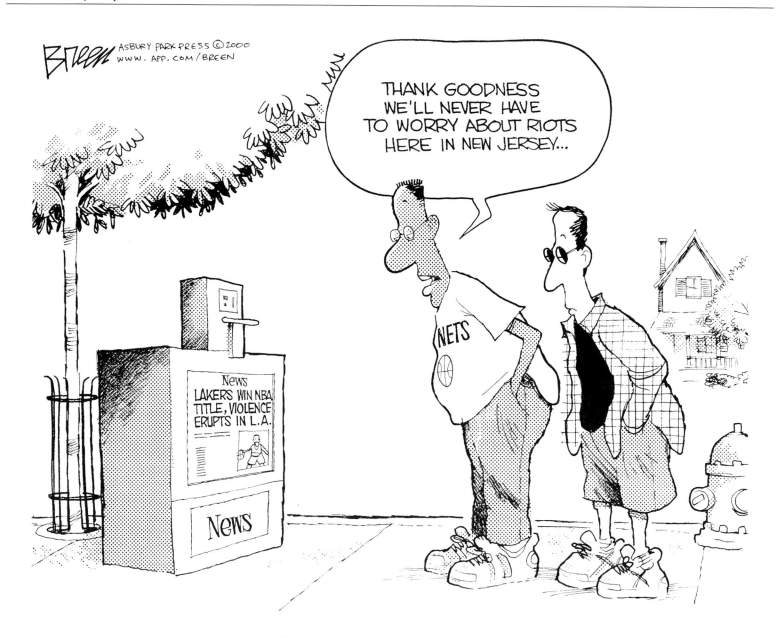

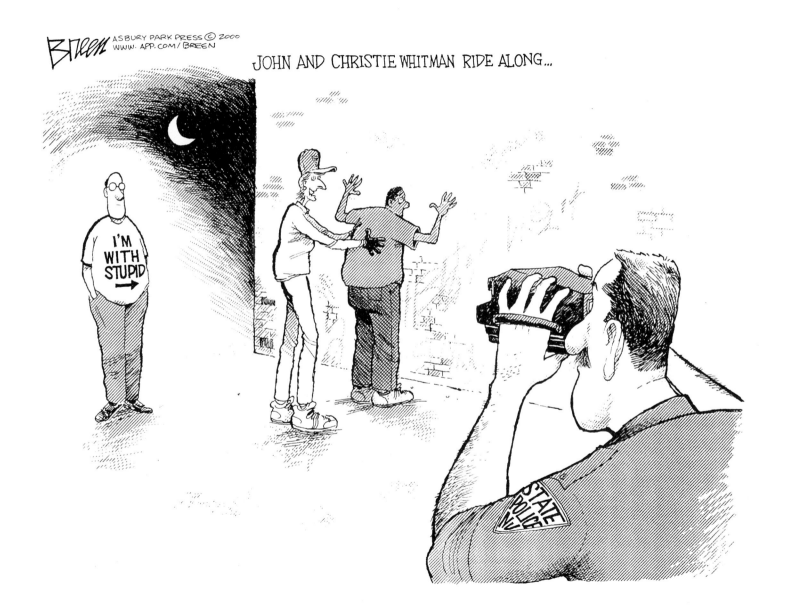

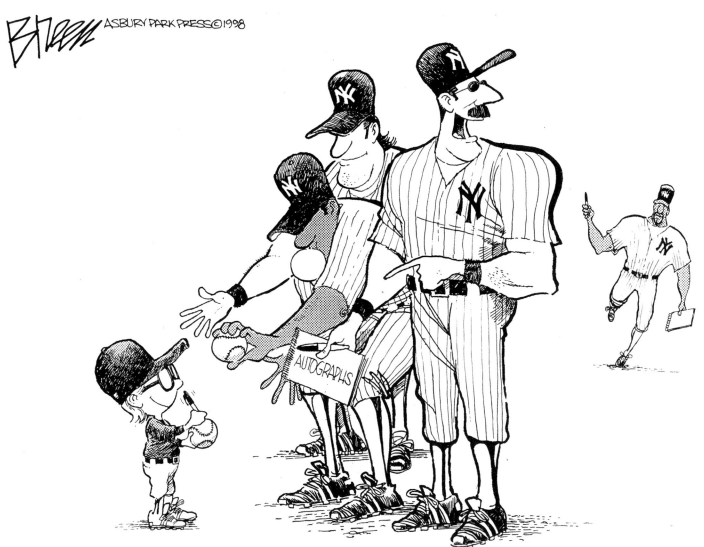

"IT'S A TOMS RIVER EAST LITTLE LEAGUER!"

Pulitzer Portfolio

12 of the cartoons that won the Prize

No one was more surprised than I.

What else can I say? Winning the Pulitzer Prize is every editorial cartoonist's dream – one that I thought, for me, anyway, would remain just that.

The following 12 cartoons are from 20 that were submitted to the Pulitzer Committee for consideration in 1998. The submissions were all in black and white. For you, we've added color.

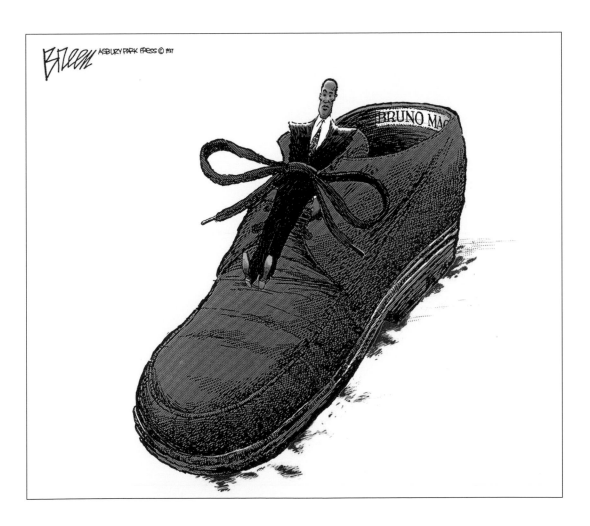

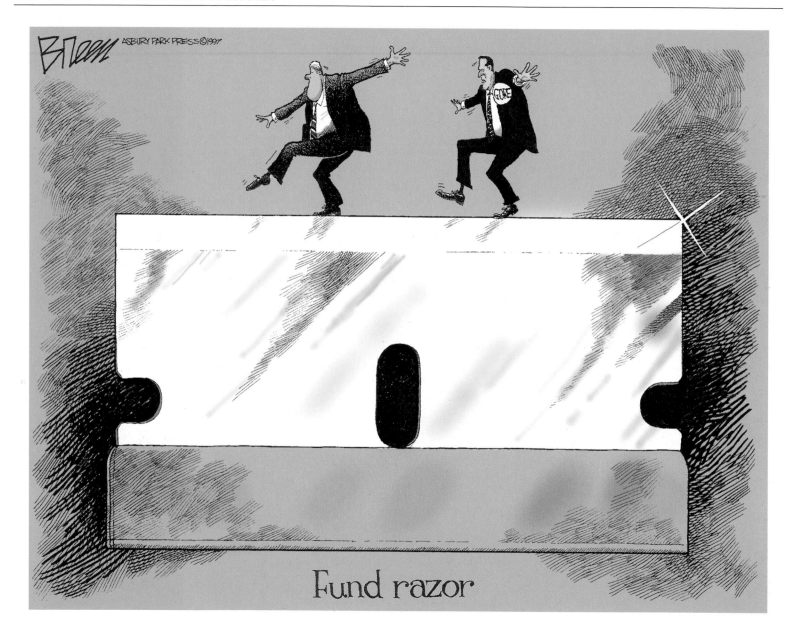

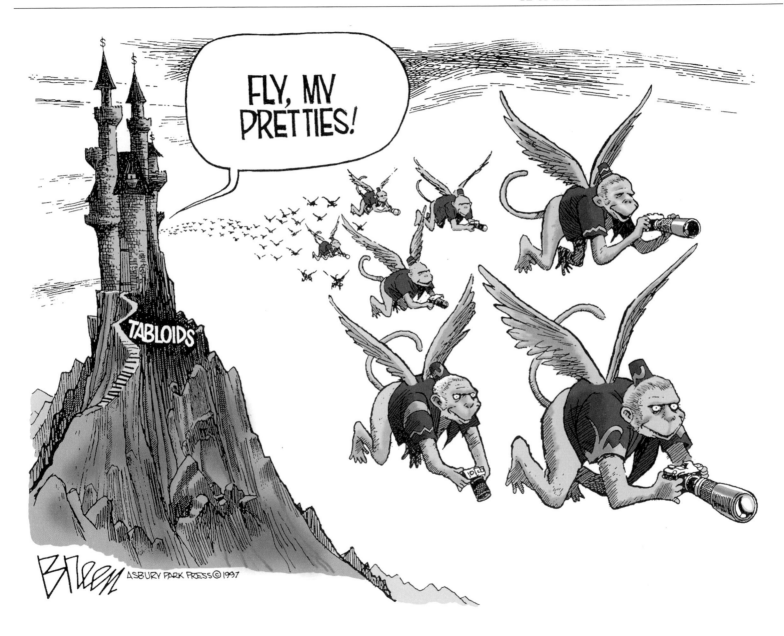

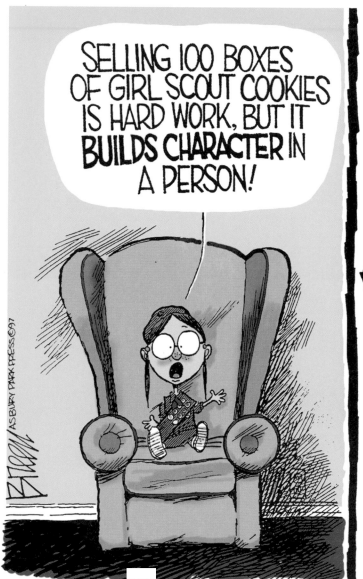

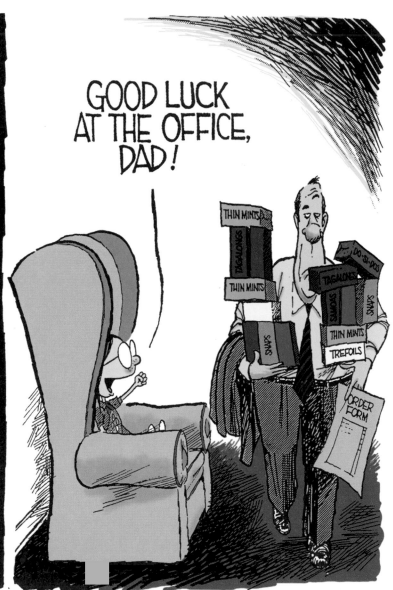

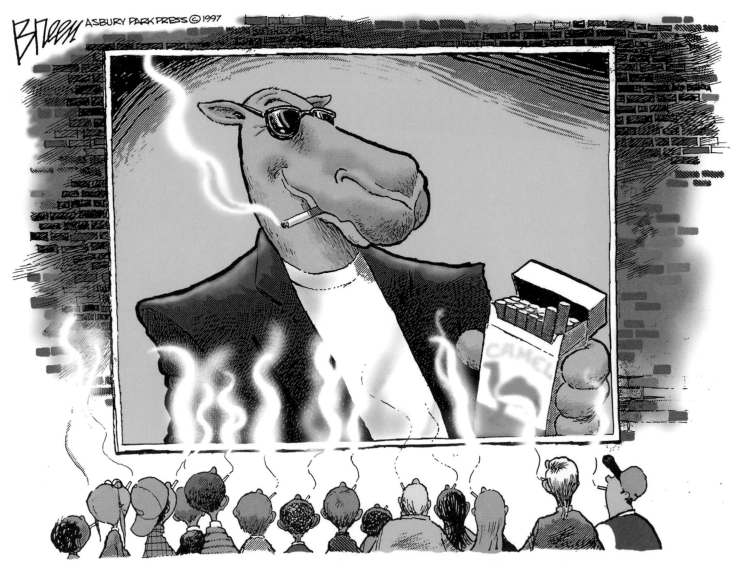

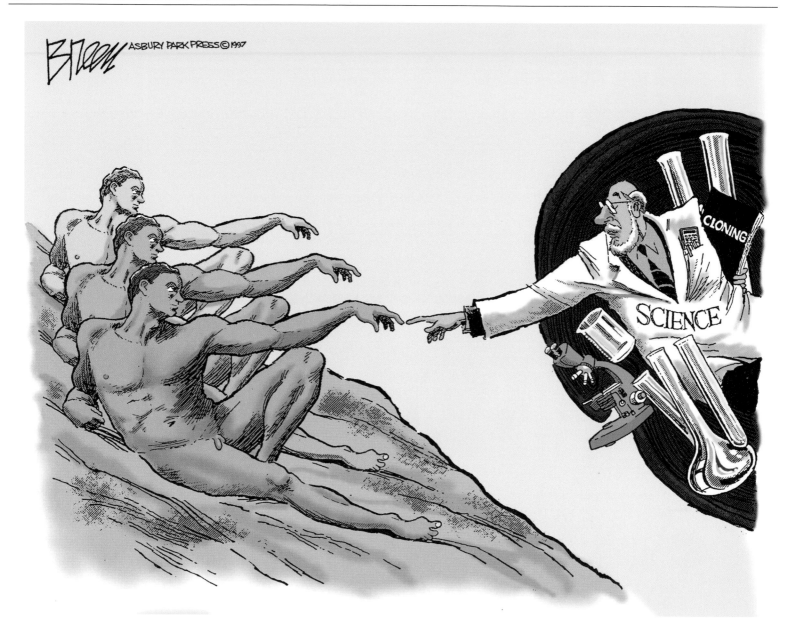

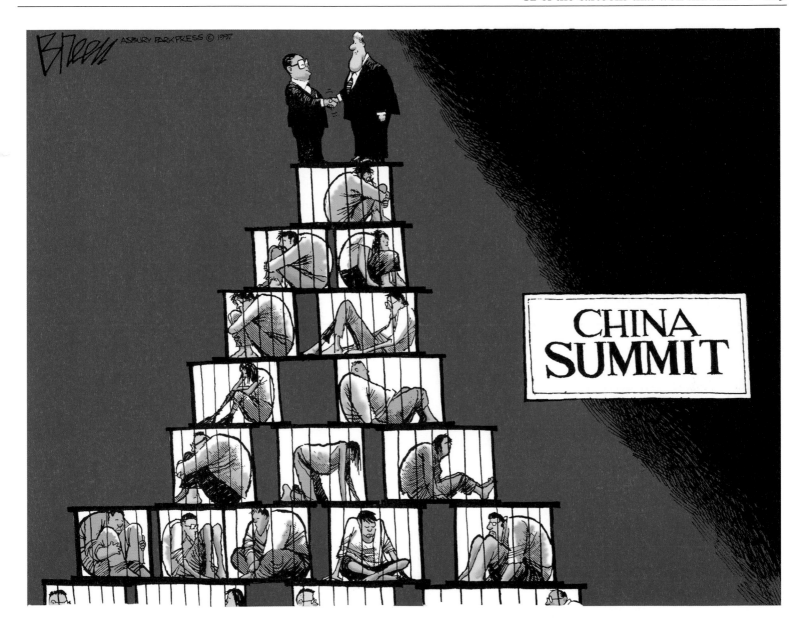

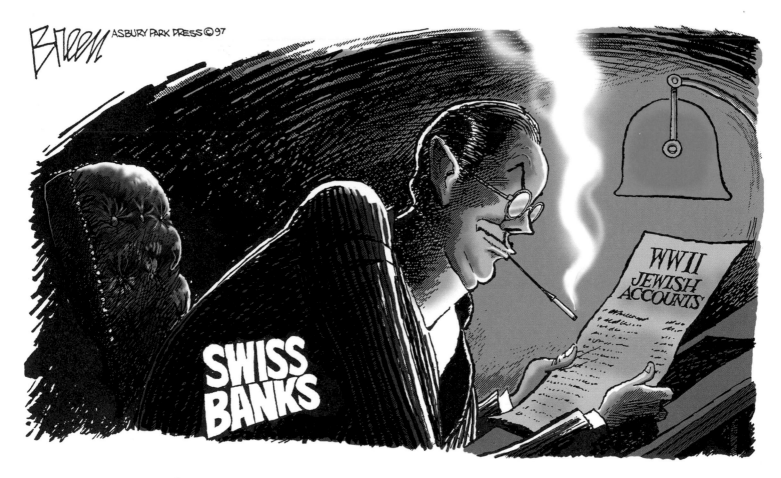

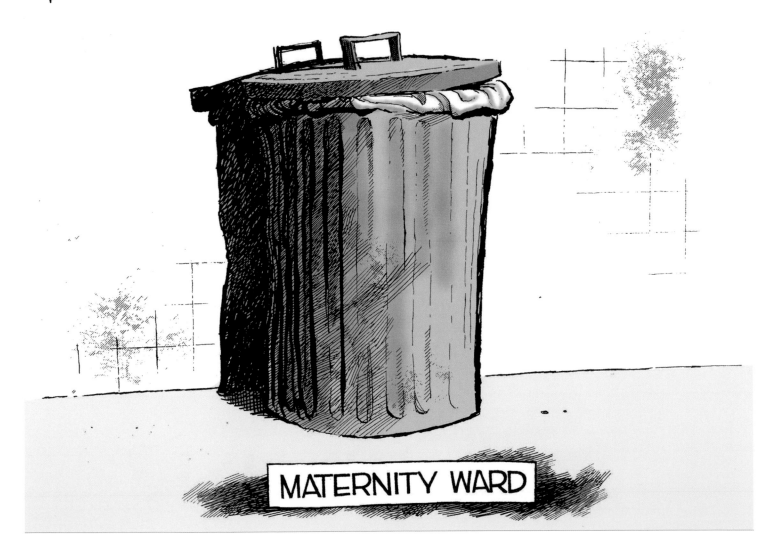

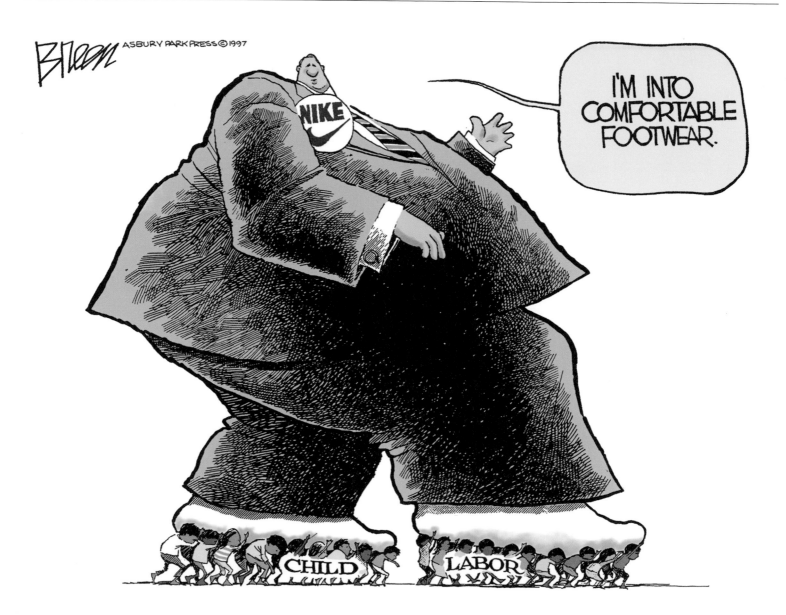

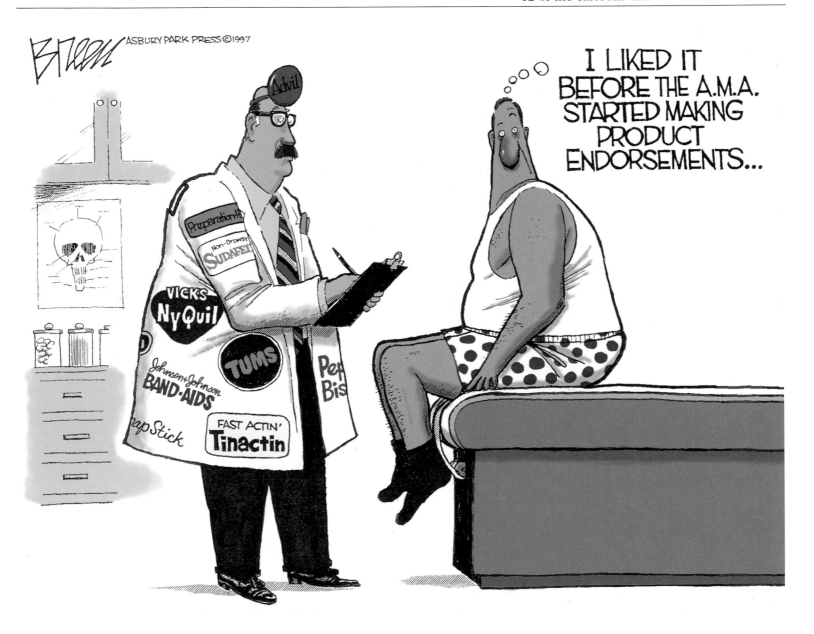

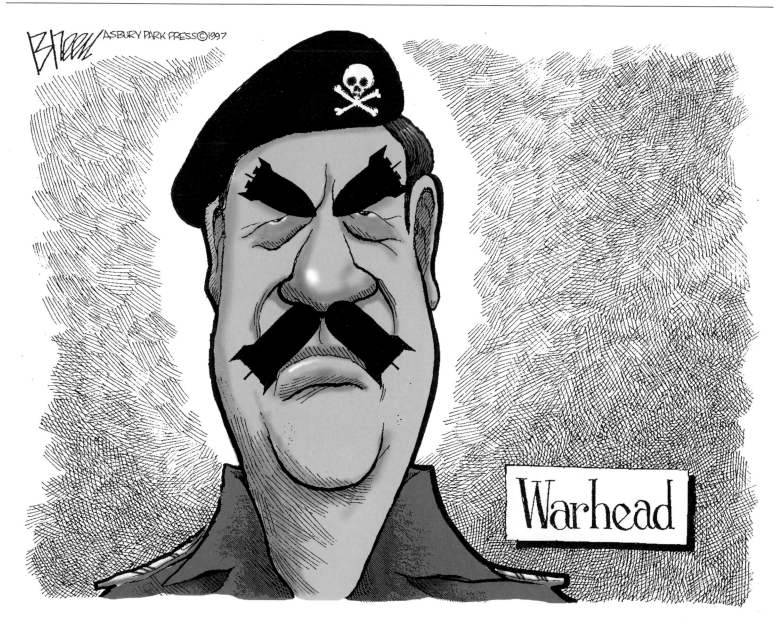